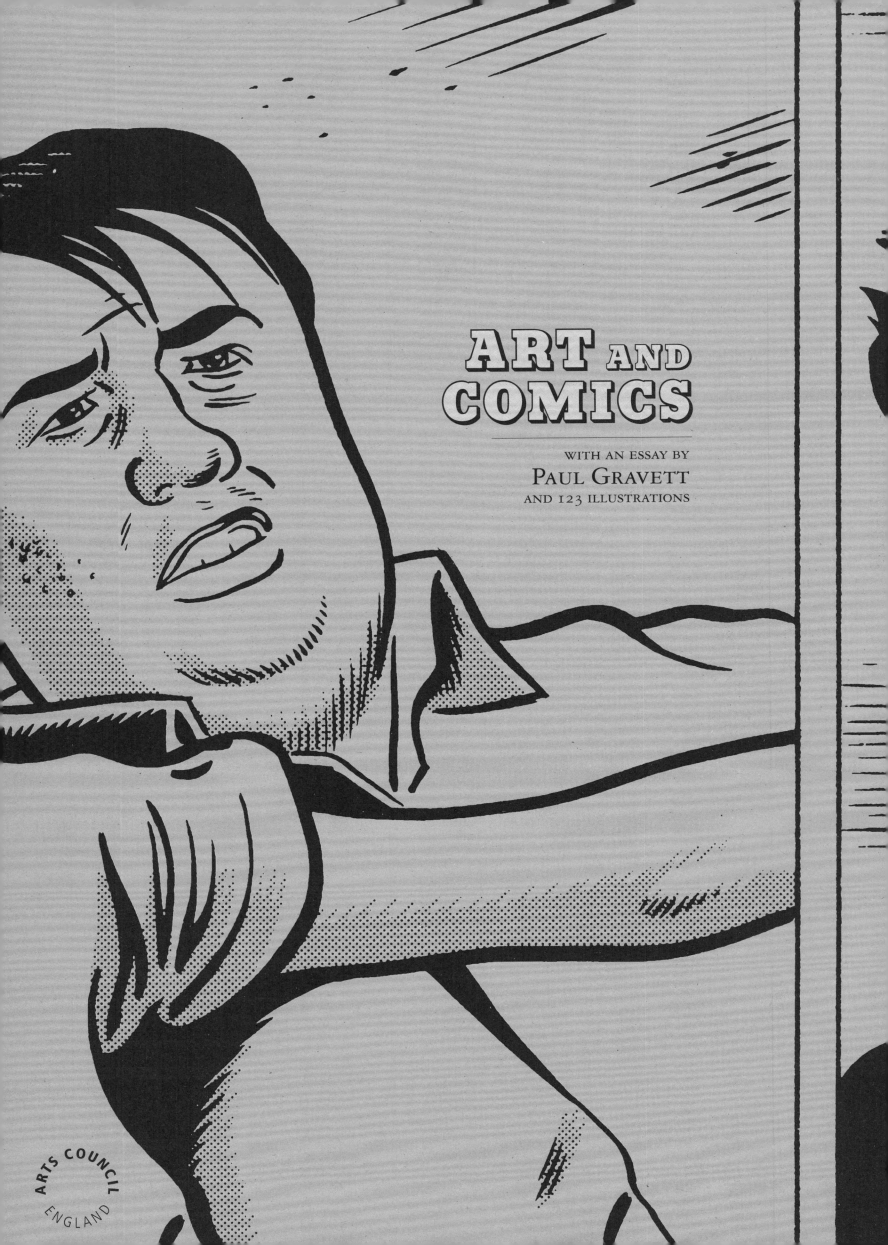

ART AND COMICS

WITH AN ESSAY BY
Paul Gravett
AND 123 ILLUSTRATIONS

ARTS COUNCIL ENGLAND

Published on the occasion of the exhibition CULT FICTION: ART AND COMICS, a Hayward Gallery Touring Exhibition
Exhibition originated by *Kim L. Pace* and co-curated with *Emma Mahony* Exhibition organised by *Emma Mahony*, assisted by *Alice Lobb*
Comics Advisors: *Paul Gravett* and *Sherman Sam*

4 May – 1 July 2007, New Art Gallery, Walsall
14 July – 16 September 2007, Nottingham Castle
21 September – 11 November 2007, Leeds City Art Gallery
17 November – 13 January 2008, Aberystwyth Art Gallery
19 January – 16 March 2008, Tullie House, Carlisle

Art Publisher: *Charlotte Troy* Publishing Co-ordinator: *Oriana Fox* Sales Manager: *Deborah Power* Catalogue Design: *Jacob Covey*

Front Cover: Travis Millard, SALLY, 2004 Back Cover: Travis Millard, RICHARD'S SWEATER, 2004 Frontispiece: Daniel Clowes, DAVID BORING NO. 21 (DETAIL), 2000
Front and Back Flaps and Front Cover of Artists' Questionnaires: Killoffer, SIX HUNDRED AND SEVENTY-SIX APPARITIONS OF KILLOFFER (DETAILS), 2002.

Published by Hayward Gallery Publishing, Southbank Centre, London SE1 8XX, UK
www.southbankcentre.co.uk
© Hayward Gallery 2007
Texts © the authors 2007

ISBN 978 1 85332 260 0
Distributed in the United States of America through D.A.P. / Distributed Art Publishers
155 Sixth Avenue, 2nd floor, New York, N.Y. 10013
Tel: (212) 627 1999; Fax (212) 627 9484; artbook.com

Distributed outside America by Cornerhouse Publications
70 Oxford Street, Manchester M1 5NH
tel. +44 (0)161 200 1503; fax. +44 (0)161 200 1504
cornerhouse.org/books
Printed on recycled paper in the U.K. by BAS Printers

CONTENTS

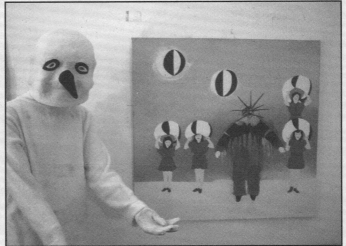

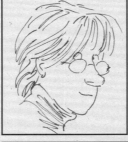

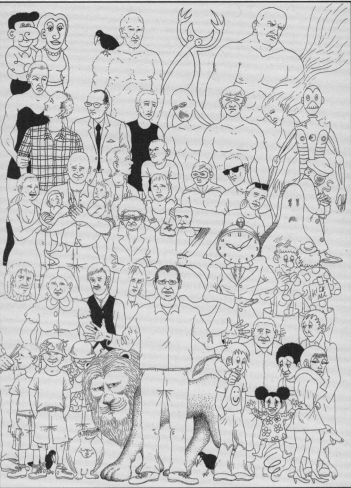

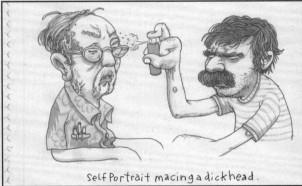

Self Portrait macing a dickhead.

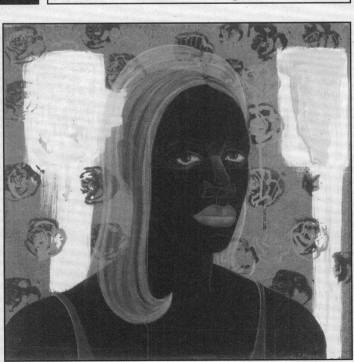

THAT WHEN HE SPAT INTO AN EYE THAT WAS BLIND OR OBSCURE, THE SIGHT WAS AT ONCE RESTORED TO IT.

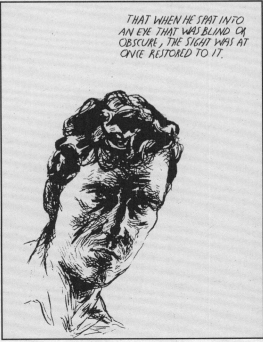

1. Daniel Clowes	9. R. Crumb	16. Glen Baxter
2. Chad McCail	10. Olivia Plender	17. Carol Swain
3. Paul McDevitt	11. Jon Pylypchuk	18. Chris Shepherd
4. Adam Dant	12. Posy Simmonds	19. Richard Slee
5. David Shrigley	13. Laylah Ali	20. James Pyman
6. Marcel Dzama	14. Kerstin Kartscher	21. Killoffer
7. Julie Doucet	15. Mark Kalesniko	22. Stéphane Blanquet
8. Melinda Gebbie		

23. Debbie Drechsler
24. Kim L. Pace
25. Travis Millard
26. Joe Sacco
27. Liz Craft
28. Kerry James Marshall
29. Raymond Pettibon

'ITS STRANGE FORM EXCITES ME IN THAT IT DOES MAKE A NEW THING – A NEW IMAGE –
WORDS AND IMAGES FEEDING OFF EACH OTHER IN UNPREDICTABLE WAYS. NATURALLY, THERE
IS NO "ILLUSTRATION" OF TEXT, YET I AM FASCINATED BY HOW TEXT AND IMAGE BOUNCE INTO
AND OFF EACH OTHER ... I THINK, HOPE, YOU'LL AGREE THAT WHEN IT IS ALL ON ONE PAGE,
A MORE INTIMATE AND STRANGE SITUATION IS CREATED...'

Philip Guston.

FOREWORD

The relationship between art and illustration is historically rich and complex, changing with each generation and the emergence of new media. In its immediacy and intimacy, though, drawing is consistently and closely connected to writing, and in most of the work in CULT FICTION, the two are interlinked. When the artist Kim L. Pace first proposed this exhibition to The Hayward three years ago, it was with the idea that drawing lies at the heart of many artists' creativity; it is where their work begins in childhood, often inspired by illustrations in books and comics. Her proposal was for a show that brought these early sources together with contemporary work. As the project developed, in discussion with Hayward Gallery Curator Emma Mahony, it has become more specific, focusing on new approaches to the comic strip, with all its narrative possibilities, in the work of both artists and comics artists.

It is 20 years since the exhibition COMIC ICONOCLASM at London's Institute for Contemporary Arts featured the work of fine artists inspired by comics. Since then much has changed. Firstly, the old hierarchical distinction between 'High and Low' (the title and subject of an exhibition at New York's Museum of Modern Art in 1990) has largely dissolved. Secondly, the hegemony of American comics is no longer absolute; Japan, France and Belgium are all at the forefront of the international comics culture. Thirdly, the medium of the comic strip has been transformed and its creative potential revealed by increasingly subtle and sophisticated treatments in ambitious and beautifully produced graphic novels.

CULT FICTION does not distinguish between fine artists and comics artists, but shows them together on equal terms. There are of course problems associated with this: illustrations intended for reproduction on the printed page are often different in kind and scale from drawings produced for exhibition. In the gallery sequential art can only been shown in extracts. Furthermore some graphic artists are loth to allow their original work to be displayed out of context, and we are therefore missing several key figures whose names are synonymous with the medium of the comic strip. In any case, the limits of an exhibition of this scale and with this particular focus preclude the possibility of exploring the genre exhaustively. What is shown here, however, is a sampling of some of the most compelling and innovative work of its kind being made today.

We thank Kim L. Pace and Emma Mahony for the commitment and enthusiasm they have brought to this exhibition and for their contributions to this book. Since Pace is primarily an artist (although one who has curated several exhibitions in the past), we invited her to contribute a 'visual essay' to the catalogue and she responded with the mini-zine CIRCUS, CIRCUS (which you will find tucked in the cover of this publication). We also thank writer and comics specialist Paul Gravett for his invaluable advice and guidance. His essay eloquently sets the tone and historical context for CULT FICTION.

A very special thanks is due to the lenders for their very generous support of this touring exhibition: Barrett Marsden Gallery, CAP Collection, Centre National de la Bande Desinée et de L'Image, Flowers Gallery, Stephen Friedman Gallery, Francis Fung, Richard Heller Gallery, Susan Hiller, Anneke Kahn, Paul Morris, Galerie Giti Nourbakhsch, The Saatchi Gallery, Jack Shainman Gallery, Timothy Taylor Gallery, Gary Witham, The Zabludowicz Art Trust, David Zwirner Gallery, and to those lenders who wish to remain anonymous.

We are delighted with the enthusiastic commitment our colleagues in the host galleries have demonstrated towards CULT FICTION from its inception and thank particularly: Emily Marsden, Deborah Robinson and Stephen Snoddy at New Art Gallery, Walsall, Jim Waters formerly at Nottingham Castle, Nigel Walsh at Leeds City Art Gallery, Eve Ropek at Aberystwyth Arts Centre and Fiona Venables at Tullie House, Carlisle.

We are grateful to Jacob Covey, Art Director at Fantagraphics Books, for his innovative and sensitive design of this book. We also thank our Hayward colleagues for their essential contributions, including: Sepake Angiama, Sophie Higgs, Helen Luckett and Natasha Smith from Public Programmes; Samantha Cox and Alison Maun from the registrar's team; Dave Bell, Steve Cook, Jeremy Clapham, Geock Brown, Nicky Goudge and Mark King from the technical team; Sarah Davies, Helen Faulkner, Gillian Fox and Kathryn Havelock from Press and Marketing. A special thanks goes to the following members of the Hayward team who have contributed texts on the individual artists: Alice Lobb, Oriana Fox, Helen Luckett, Emma Mahony and Sherman Sam.

We would also like to thank the following whose support has made the exhibition possible: Philly Adams, Amy Baumann, Adam Baumgold, Peggy Burns, Silvie Buschmann, J.J. Charlesworth, Natalie Court, Sarah Edom, David Green, Paul Hedge, Alan Hewson, Keiko Higashi, David Hubbard, Alison Jacques, Ann-Marie James, Russell Jenkins, Nadia Katz-Wise, Jonathan Kennedy, Loannis Loannou, Laura Lord, Emma McKeown, Jean-Pierre Mercier, Simone Montemurno, Kari Morris, Elizabeth Neilson, Chris Oliveros, Amanda Phillips, Brian Powney, Mark Rappolt, Zoe Renilson, Cathryn Rowley, Judy Sagal, Cath Sherrell, Daelyn Short, Vicky Skelding, Sally Smith, Lisa Spelman and Anita Whelan.

Finally, we owe our largest debt to the artists, for their generous commitment to this exhibition.

Ralph Rugoff, Director, Hayward Gallery
Roger Malbert, Senior Curator, Hayward Gallery Touring

CURATORIAL PREFACE

I first encountered Alfred E. Neuman's mischievous grin, jug ears and missing tooth on the covers of MAD magazine at my cousin's house when I was about 10. A stack of MAD comics became mine as I progressed from the BEANO and RUPERT. It was not only the drawings and photo-collages that appealed, but the irreverent humour too. (In recent years, MAD Magazine's mascot, with his eternal question, 'What me Worry?', has become a universal symbol of unquestioning stupidity, his features frequently merged in political cartoons with those of George W. Bush.)

As a teenager, romantically charged photo-stories and pop trivia magazines replaced my interest in comic books, but there is no doubt that early reading material such as comics and illustrated storybooks has made a lasting impression on my consciousness as an artist.

Not everyone seems so convinced of the positive impact of popular material on visual artists: on the radio recently, I heard a well-known art commentator asserting that the current generation of artists have grown up starved of anything visually worthwhile; instead they feed on a diet of comics, cartoons and films, 'mere' popular culture – the inference being that these forms are bereft of anything original or authentic for an artist to refer to. I think this precisely overlooks the point. Artists cannot separate themselves from the rest of culture; they are a part of it. The hugely influential mass media, reproductions, novels, comics, computer games and books full of luscious imagery are ubiquitous in the world we now inhabit, a world in which many people are said to spend, on average, one year in every ten watching television, where hours are lived out in virtual space and where people sometimes stay longer in gallery bookshops than in the exhibitions.

CULT FICTION represents a tiny fraction of the phenomenal range of graphic invention – often accompanied by words – that is currently being produced in the comics format. This selection deliberately avoids the separation of 'comics' artists and 'fine' artists; instead our aim has been to suggest the huge potential of this inexpensive and accessible medium as an alternative means of distributing imagery, critique, contemporary narratives and ideas.

Kim L. Pace

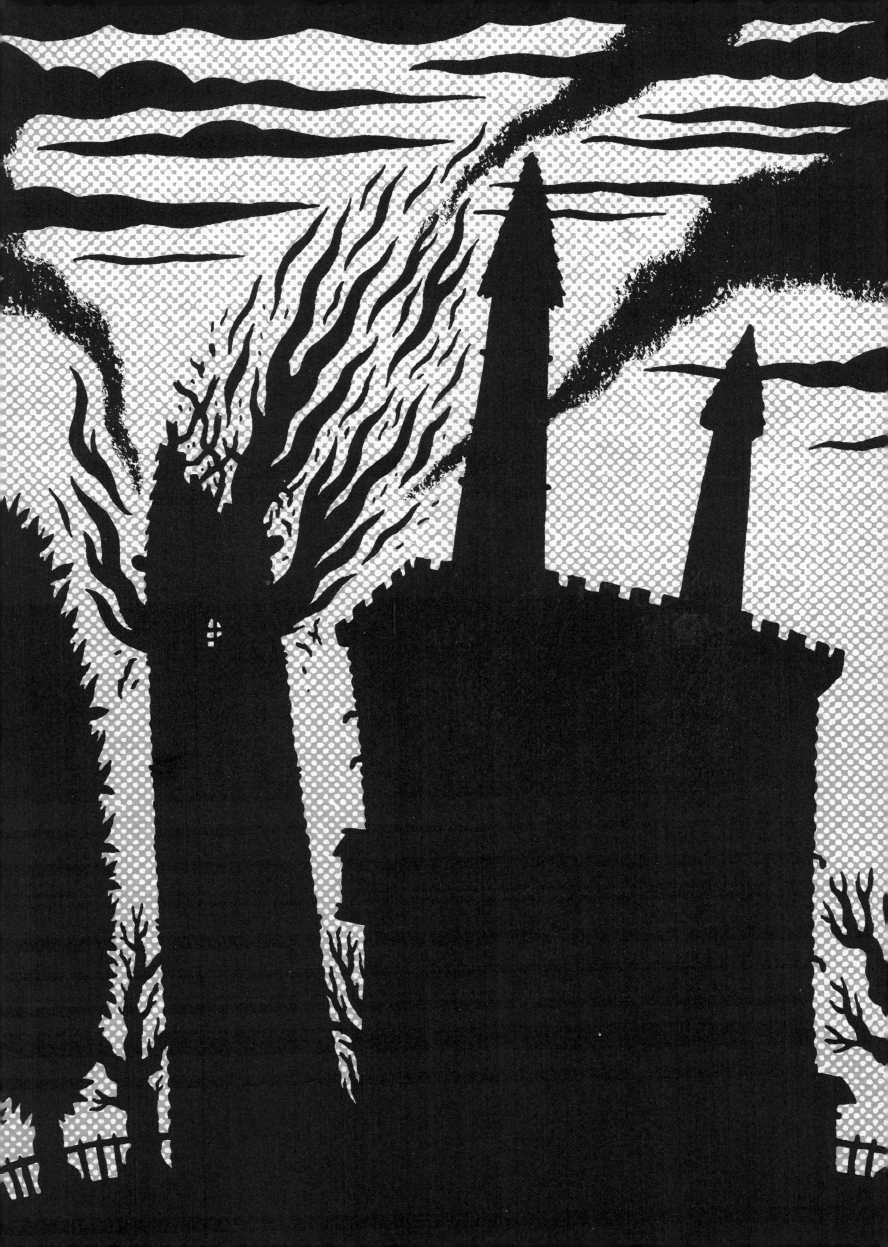

an INTRODUCTION to

Cult Fiction

IN CULT FICTION, THE RELATIONSHIP BETWEEN COMICS AND CONTEMPORARY ART COMES UNDER THE SPOTLIGHT.

The comics medium offers a unique form of communication where word and image combine to follow the exploits of characters through space and time and often across the pages of multiple issues. Its ostensibly 'innocent' form allows for the dissemination and articulation of difficult ideas in an accessible manner, providing a platform for political and social commentary as well as a vehicle for escapism, introspection and deviance. The comic book's appeal to contemporary artists is rooted in this visual language and its potential for pictorial storytelling. Unlike Pop artists, who were famously concerned with 'iconic quotation' – the appropriation of recognisable characters and iconography from mainstream comics – today's generation of artists work mainly from inside the medium combining linguistic and visual signs to drive their narratives. It is a reciprocal relationship, which goes beyond sharing a visual vernacular to representing similar subject matter. Current social and political issues as well as personal concerns and everyday lived experience are aired in frank visual narratives where comedy and tragedy commingle.

As the title signifies, the literature in CULT FICTION exists on the margins of the conventional and challenges mainstream culture – the commercial comics industry – while the fine artists who respond to this medium in turn challenge the premises of Pop Art, which looked to this mainstream industry in its eagerness to engage with the epitome of popular culture. The comics artists are mainly of the independent author-draughtsmen variety, and more often than not their subject matter is off-beat and transgressive, sometimes perverse and occasionally controversial. Stylistically, the comics engage with high art conventions in both their visual and narrative eloquence. Publishing houses like Fantagraphics Books (which publish the work of several of the comics artists in this exhibition) purport to produce comics for 'thinking readers – readers who like to put their minds to work, who have a sophisticated understanding of art and culture, and appreciate personal expression unfettered by uncritical use of cliché.' They also state in no uncertain terms what they are not about: 'any submissions that fit neatly into (or combine in a gimmicky fashion) the mainstream genres of superhero, vigilante, horror, fantasy, and science fiction will practically always be rejected.'

The genesis for the comics represented here can be traced back to the 1980s and 90s and indeed includes several of the comics greats who came to prominence in this period. The 1980s saw the emergence of this new breed of artist-published anthologies spearheaded in the United States by RAW magazine, edited by Art Spiegelman and François Mouly, which promoted the work of Chris Ware, Daniel Clowes, Charles Burns and others. Following close on their heels, R. Crumb edited WEIRDO, an anarchic collection of underground and deviant material, including, of course, his own work. Both RAW and WEIRDO kept abreast of the fine art vernacular, the former adopting the tag line 'High Art for Low Brows' and the later, featuring the work of Raymond Pettibon. Across the water in Paris, a group of comics artists including Killoffer founded L'ASSOCIATION in 1990, a collective which aimed to produce an alternative to the mainstream BANDE DESSINÉE (comics like TINTIN and ASTERIX). This was later followed by OUBAPO (Ouvroir de la Bande Dessinée Potentielle), a collective of avant-garde comics artists who set themselves unusual problems to solve.

For the generation of comics artists represented in CULT FICTION 'real life issues', often approached in biographical or autobiographical styles, supplant moralistic tales of good and evil. Their protagonists stand on the margins

Stéphane Blanquet, LA VÉNÉNEUSE AUX DEUX ÉPERONS (Detail), 2001 | OPPOSITE
Laylah Ali, UNTITLED (Detail), 2002 | ABOVE

of society displaying sexual, gender, ethnic, racial or class attributes which don't fit the cultural standard. The superhero of mainstream comics has been replaced with an everyday anti-hero (a character who ultimately performs 'heroic' acts but with methods or intentions that may not be perceived as heroic) – as personified by Harvey Pekar's file clerk in AMERICAN SPLENDOR, a character who proposes the existential idea that getting out of bed could be a heroic act. Daniel Clowes' 'ordinary, heroic, misfit' David Boring is a near relation. In other instances, the protagonist is replaced with an antagonist, an objectionable character with whom it is difficult to identify or empathise, as in Mark Kalesniko's graphic novel MAIL ORDER BRIDE where the protagonist is a seedy comic book geek.

The diaristic and autobiographical tales of this genre are often extremely candid in their characterisation. In Julie Doucet's NEW YORK DIARY she has no compunction in revealing her character in vulnerable and compromising situations. Likewise, Debbie Drechsler recounts unsettling tales of childhood abuse from an adult perspective. Killoffer takes autobiography to an outlandish and self-obsessed extreme in a tale of his 676 clones.

In another approach, the pictorial iconography of the comic book is used to air current affairs in a journalistic-style. With a nod to Art Spiegelman's groundbreaking and Pulitzer prize-winning MAUS, Joe Sacco employs eye-witness reportage in his sensitive and accessible comic book accounts of life in centres of conflict.

For the most part, the comics in CULT FICTION are aimed at adults and the content, like that of Drechsler and Killoffer, is often explicit. Alan Moore and Melinda Gebbie push the boundaries even further in their graphic novel LOST GIRLS, which portrays the sexual awakening of a posse of characters from children's literature – Alice from ALICE IN WONDERLAND, Dorothy from THE WIZARD OF OZ and Wendy from PETER PAN – as told by their older selves. Classic literature is also the starting point for Posy Simmond's GEMMA BOVERY, which is loosely based on Flaubert's tale of the adulterous heroine Madame Bovary. Simmond's graphic novel reinterprets Flaubert's tale, setting it in present-day Normandy.

Stylistically, these comics introduce new and sophisticated visual apparatuses and methods. Killoffer employs an innovative graphic style in which the traditional grid structure gradually dissolves as the story progresses, allowing the drawings to spill chaotically across the page, only reverting to individual frames towards its ending. Carol Swain's narrative, with its minimal use of language, is driven forward by the strong graphic style of

her heavy charcoal drawings which echo the desolate landscape of rural mid-Wales and the alienation of her characters.

This graphic 'cult fiction' is mainly geared towards a select following of fanatical readers and is produced in smaller print runs by niche publishing houses. Many of the comics artists began by self-publishing their work, an approach also embraced by the fine artists who are attracted to the format for its ability to reach and influence a wider audience than a gallery context would permit, but who lack the publishing infrastructure. Adam Dant, Kerry James Marshall and Olivia Plender have produced comic books and strips on this premise. Adam Dant's first foray in the comic book format was biographical; he produced a journal in the guise of his alter ego 'Donald Parsnips' every day for five years, which he distributed free to random

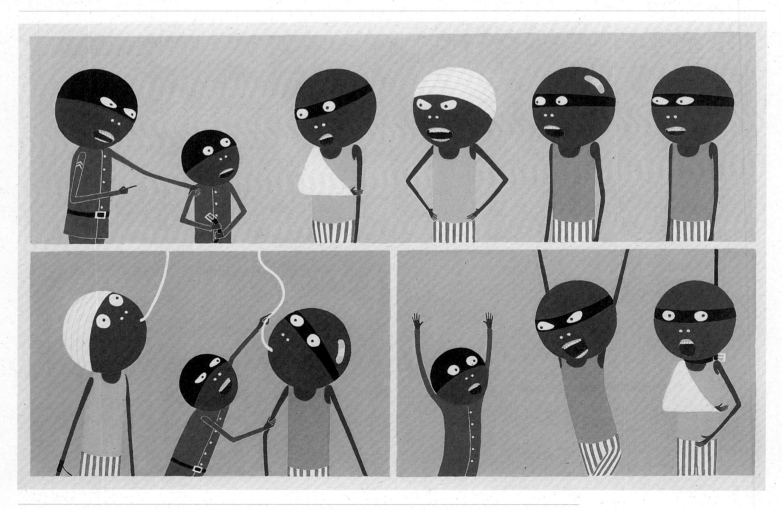

ABOVE Yoshitomo Nara and David Shrigley, UNTITLED (IF YOUR SOUL IS NOT.....), 2002
BELOW Laylah Ali, UNTITLED (Greenheads), 1998

passers-by. Since 2001, Olivia Plender has been largely occupied with the production of THE MASTERPIECE, a pencil-drawn comic book based on cut-and-pasted cultural references from historical sources, screenplays and other comic books. The impetus for Kerry James Marshall's newspaper comic strip RYTHM MASTR was twofold – he wanted to address the under-representation of African Americans by the mainstream comics industry and, like Plender and Dant, to situate the comic book medium in a fine art context and thereby question its cultural value.

For these artists the democratic format of the medium, its production and distribution methods (where anyone can own a copy) remains key to their interest, subverting the premise of the unique and hence valuable artwork. Plender's THE MASTERPIECE bears this dichotomy at its very heart. By giving away (or selling for £1), a comic which is both entitled 'The Masterpiece' and tells the tale of its protagonist's quest to produce such a perennially sought-after work, she deliberately chooses to work with a mass-produced medium to critique the value system of high art. Working to a similar end, when commissioned to make new work for a solo exhibition, Marshall produced RYTHM MASTR as a newsprint comic and displayed the individual pages pasted to the glass fronts of museum display cases, mimicking the window fronts of empty shops where newspaper is used to block the view from the street.

Glen Baxter, James Pyman and Chad McCail produce drawings that combine image and caption, a format typical of newspaper cartoons. While stylistically similar to the work of commercial cartoonists such as Gary Larson, Baxter's drawings are atypical in their monumental scale and tonal treatment, created with layers of coloured crayon. In McCail's paintings his bold moralistic slogans at first appear to support the image they caption, but in fact often contradict it. Unlike Baxter and McCail, who locate their 'cartoons' in the realm of fine art, James Pyman is keen for his single-frame cartoons to be 'read' as commercially-produced work. His publication of newspaper cartoons, THE LIFE OF WILF, is premised on the fiction that they represent the life's work of a newspaper cartoonist over the course of a 30 year career.

David Shrigley, Raymond Pettibon and Kim L. Pace also combine word and image but in a looser, more ambiguous way. Shrigley's text rarely serves to describe the image, and similarly, the image never quite illustrates the text it accompanies. Instead, his scrawny, often misspelt, handwritten texts act as subconscious annotations to his drawings, inviting the viewer to project their own readings. Occasionally text replaces the image altogether, playing instead on the visual quality of his handwriting. In her work, Pace appropriates both text and typography from sources such as album covers and theatre bills. Like Shrigley, she is interested in the visual quality of each word as an image in its own right, a consideration which is as important to her as the words' meaning. For Pettibon, who often annotates his drawings with extraneous literary quotes, the text adds an incongruous and unsettling dimension.

Certain graphic elements of comic book imagery appeal to this generation of fine artists, giving them the freedom to make works that hint at or suggest narrative without the use of words. Kerstin Kartscher, Laylah Ali and Marcel Dzama employ a similar reductive strategy, based on a limited palette of saturated colours within inked outlines. This iconography suggests an ongoing or inexhaustible narrative, of which a drawing represents just a frozen moment culled from an overarching sequence. A similar principle can be applied to the three-dimensional work of Liz Craft, Richard Slee, David Shrigley and Jon Pylypchuk. In Pylypchuk's tableaux a recurring cast of 'down at heel' furry creatures interact in what appears to be an endless cycle of violence. Similarly in the drawings of Marcel Dzama and Laylah Ali their characters appear to engage in neverending power struggles. Presented as hermetic narratives, we are party only to a fleeting moment, often the aftermath of what we imagine to have been one of a series of unpleasant encounters.

In other instances, a consistent stable of characters and images obviate the need for language, or in the case of Laylah Ali's work, replace it. She describes her idiosyncratic figures as representing individual letters in her own invented alphabet. Likewise, in Dzama's drawings bats, bears, anthropomorphic trees and uniformed men and women brandishing knives appear time and again, and in McDevitt's drawings flightless birds and ghosts are recurring subjects.

While narrative – whether textual or visual – is the driving force of this exhibition, some of the artists are not primarily interested in the depiction of sequential or straightforward stories but choose to subvert or complicate narrative structures. Dzama and Ali's characters appear to float in the centre of otherwise blank pages, denying us any contextual information to help locate

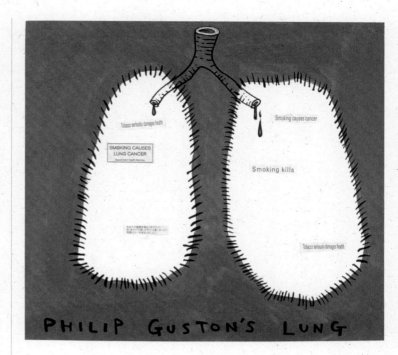

them in time or space. Shrigley's fragments of subconscious thought further confuse the reading of his drawings. When he first exhibited pages of RYTHM MASTR, Kerry James Marshall chose to display the double-sided pages so that they overlapped, and in lighting them from behind, the images on the reverse became visible, thus making both sides illegible. Other artists employ devices such as fragmentation and flux and the displacement of identities.

In an arena where contemporary artists are exploring smaller-scale, more intimate media, including drawing, writing and publications, not as secondary avenues but as their primary means of expression, CULT FICTION recognises their indebtedness to comic iconography. The appeal of an accessible language to convey 'difficult' ideas, coupled with the medium's narrative potential and distribution beyond the art gallery network, is especially alluring, as is fine art's desire constantly to question and subvert its own boundaries by engaging with other popular media. Whether the comics artists welcome this new and more forgiving advance into their territory is debatable; they certainly didn't when the Pop artists stole their characters and formats wholesale. But what this exhibition is trying to say is that the traffic goes both ways; both sides are engaged in a reciprocal relationship. They each take the language of comic iconography and make it their own.

Emma Mahony

Yoshitoma Nara and David Shrigley, UNTITLED (PHILIP GUSTON'S LUNG), 2000 | ABOVE

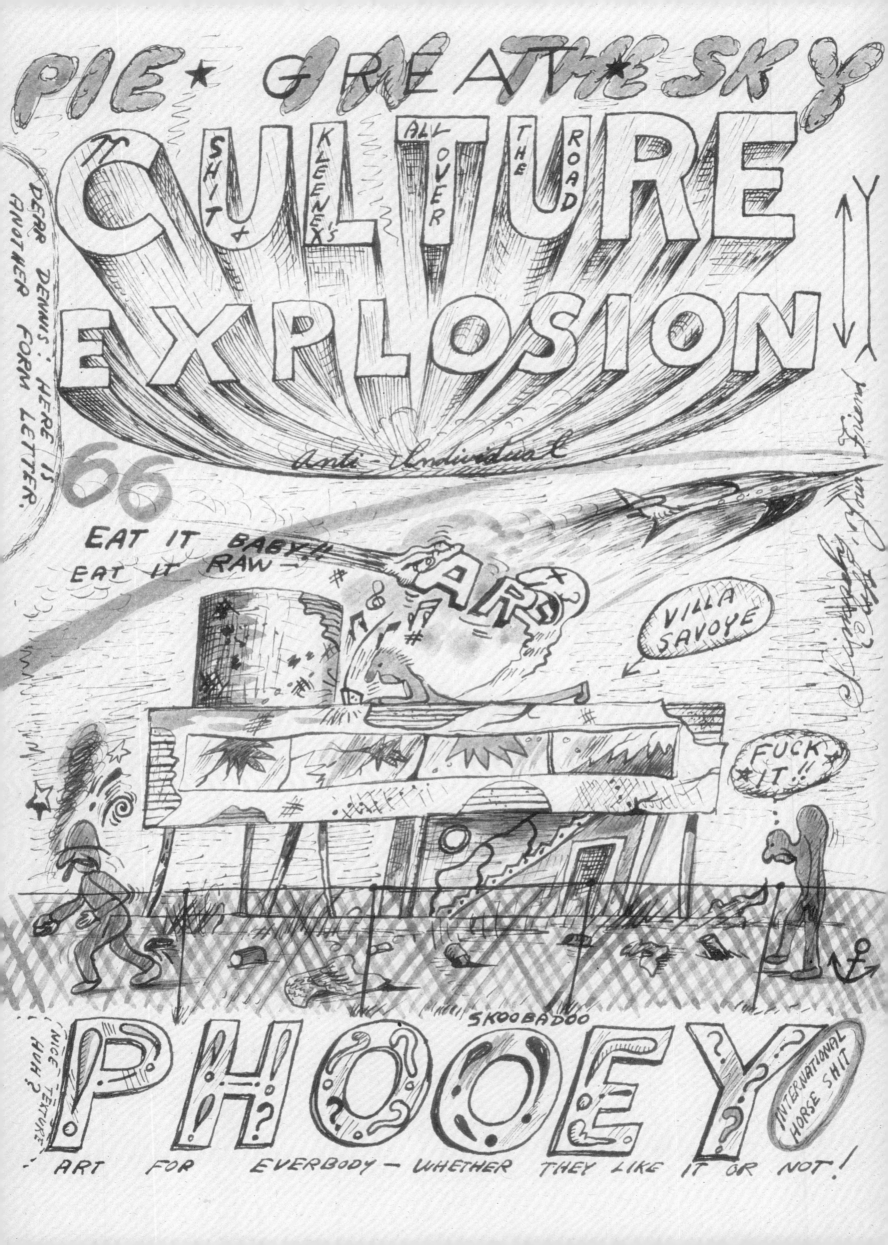

INTIMATE & STRANGE SITUATIONS — *by Paul Gravett*

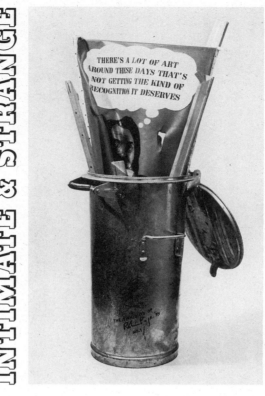

A PAINTING HAS BEEN SMASHED UP AND STUFFED INTO A WASTE BIN. IT'S THE ULTIMATE IN ART CRITICISM.

Not just any painting, but an artist's self-portrait from 1973, out of which floats a thought balloon saying: 'There's a lot of art around these days that's not getting the kind of recognition it deserves.' In fact, quite a lot of art directly or more obliquely inspired by comics, was getting some recognition at the time. A year after its creation, this work—THE THOUGHTS OF ROBIN PAGE NO. 1—was part of the Fluxus artist's solo show, 'Off to the Front in the Great Art War', in 1974 in Düsseldorf's Kunsthalle. Also exhibited were Page's originals of a four-page comic strip which he had produced in 1970 about some of his past performance pieces, dating back to THE DOOR in 1962, told in a mock-remorseful romp starring his bald, bare alter ego Whildon. A fine artist like Page might have been allowed to exhibit comics in art galleries back then, but the commercial comic artists toiling in the industry were generally not so welcome. Why should they be, when they had never set out to produce something to be elevated by being exhibited on gallery walls? They were drawing entirely for reproduction and publication. Should it not be enough that their recognition came from the millions of readers who read and enjoyed their printed stories and who might happily throw them away later into a waste bin?

Nevertheless, Page's thought balloon hovered over the heads of a fair few comics professionals, disgruntled at the high profile and high prices commanded by certain fine artists who appropriated from the very comic strips and comic books they drew and craved a little of that recognition and riches. It is telling that even someone as successful as Will Eisner responded to an invitation to the opening of a comics-inspired Pop Art exhibition in New York in 1974 with the outburst, 'Oh boy! We're finally being invited into the arena.' Also on the guest list were his fellow veterans of American comic books, Harvey Kurtzman, creator of the satirical MAD, and Joe Kubert, artist and editor of the sort of war comics whose panels Roy Lichtenstein had borrowed and repainted as high-priced canvases. On the night, however, Eisner's delight quickly evaporated: 'I realised we were brought in for novelty value – the weird guys who did those crazy comic books.'[1]

On a positive note, Eisner's snubbing probably helped to motivate his decision to postpone any retirement plans and devote himself to proving, to himself as much as anyone, what the comics medium might be capable of when liberated from relentless deadlines, exploitative publishers and adolescent or family-friendly blandness. He chose, however, not to pursue this goal through an unwelcoming art 'arena'. Eisner preferred to focus on raising comics' credibility as literature by popularising lengthy, serious stories in book form able to appeal to adult readers. By the following year, 1975, his first was already underway, a quartet of searing memoirs of his Jewish Bronx childhood. His struggle to find a publisher willing to gamble on his odd 'graphic novel' finally ended in 1978. The candour and human-

ity of A CONTRACT WITH GOD and his commitment to graphic novels for the rest of his life set an example and challenge to his peers and to successive generations. Eisner lived to see comics achieve something of the acceptance in America to which he had aspired, both literary and artistic. Evidence of the latter came when he was selected as one of the century's 15 most significant MASTERS OF AMERICAN COMICS for an unprecedented exhibition of artworks and artefacts, over 900 in all, so massive that it filled both the Hammer Museum and MOCA in Los Angeles. An invitation to this opening in September 2005 never reached him; he had died nine months earlier.

Although misapprehension and mistrust have abounded on both 'sides' between the worlds of comics and art, closer examination reveals how much fruitful cross-pollination has taken place, not only, as shown in this exhibition, between today's new 'Golden Age' of the global graphic novel movement and fine artists' renewed interests in using comics' elements to explore and explode narrative, but also throughout history. All the diktats that art and literature should be kept strictly apart and pure never prevented images, in sequence, incorporating text and unfolding stories, from flourishing in some form. German cartoonist and theorist Andy Konky Kru has compiled hundreds of 'early comics' as far back as 300 AD.[2] Most comics have until quite recently fallen 'below the critical radar', to use Art Spiegelman's phrase, and that may not have been a bad thing. Daniel Clowes commented, 'I can do what I want and not feel self-

conscious. I don't feel I have to impress Clement Greenberg.'[3] Clowes is not the only comic artist to worry that attracting more attention to the medium may undermine its relative liberties.

On the other hand, because of this lack of broader cultural awareness, it can still come as a surprise to some that comics are not always divorced from the other arts of their times and can equally respond to and impact on those arts' changing practices. Ignorance, if not prejudice, may explain why major surveys, such as those on Art Nouveau, Art Deco or Modernism at the Victoria and Albert Museum, can embrace everything from advertisements to kitchenware, but rarely refer to how these movements were visibly reflected in comics. The exquisitely coloured elegance of Winsor McCay's LITTLE NEMO IN SLUMBERLAND pages epitomises Art Nouveau for the masses, read by millions free with their Sunday paper. George McManus' BRINGING UP FATHER, another American

classic, would have demonstrated the public's appreciation of Art Deco, while George Herriman of KRAZY KAT fame has been appraised by Adam Gopnik as a crucial 'intermediary' figure or 'missing link' in art history.[4]

Comics more broadly have been the 'missing link' in most twentieth-century art history primers. It is as if their role in providing easily accessible stories to a broad public means that they were out of synch with numerous changes in thinking about art. Yet their role has sometimes been significant, and may well prove to be again in the twenty-first century, so some perspective might be useful. One of the most revolutionary turning-points in modern art was Cubism as developed by Pablo Picasso. Of the many influences behind this, one that has only recently begun to be understood is his voracious passion for the big broadsheet pages of the 'Sunday funnies'. According to THE AUTOBIOGRAPHY OF ALICE B. TOKLAS, in Paris in 1906 she and Gertude Stein gave Picasso a bundle of imported papers: 'He opened them up, they were the Sunday supplement of American papers, they were the Katzenyammer kids.[5] Oh oui, Oh oui, he said, his face full of satisfaction, merci, thanks Gertrude, and we left'; a later passage reveals that he 'brutally refused' to hand one over to his then-partner Fernande.

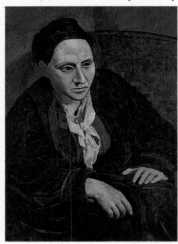

After countless sittings, the face that Picasso finally painted in his pivotal portrait of Gertrude Stein came '...out of his head'. We know that comics, with their caricatured and repeatedly drawn faces, were in his head and that he had tried them himself. Last year, the Musée Picasso brought to light five extant drawings from a six-panel sequence about his trip from Barcelona to Paris via Mountauban in 1904. So it may not have been so 'blasphemous' for art critic Jonathan Jones to suggest in 2002 that '... it was the distorted, vibrant, violent, grotesque, fantastically modern graphic world of the American newspaper comics that helped Picasso break out of every convention of continuity in art, that helped him paint a portrait that is a cartoon, but with gravitas.'[6]

It might be seen partly that rejection of the narrative and figurative preoccupations of comics, and more broadly of most commercial and fine art, lay behind the American-led Abstract Expressionist movement towards supposedly pure art untainted by the anecdotal. Comics therefore became a refuge, or a ghetto, for representational artists who wanted to draw more or less realistically tales of fantasy, superheroes, romance, crime, war or other genres. In his search for '... a painting that was despicable enough so that nobody would hang it'[7], it was precisely their pariah status in art circles that made such comics so alluring as 'found objects' to Lichtenstein in the early 1960s. Far from shocking the

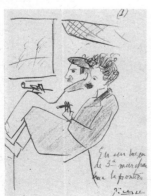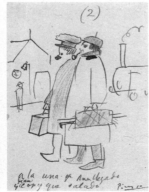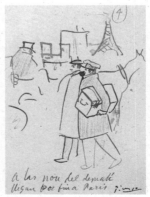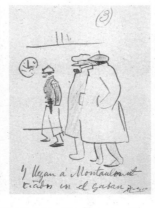

CLOCKWISE Rudolph Dirks, THE KATZENJAMMER KIDS GO TO SCHOOL!, 1903

FROM Rudolph Dirks, MAMA KATZENJAMMER, 1902. This image was found by Craig Yoe and it appears in his book ARF MUSEUM, Fantagraphics, Seattle (2006).

ABOVE Pablo Picasso, GERTRUDE STEIN, 1906

LEFT Pablo Picasso, six-panel sequence about his 1904 trip from Barcelona to Paris via Mountauban, 1904

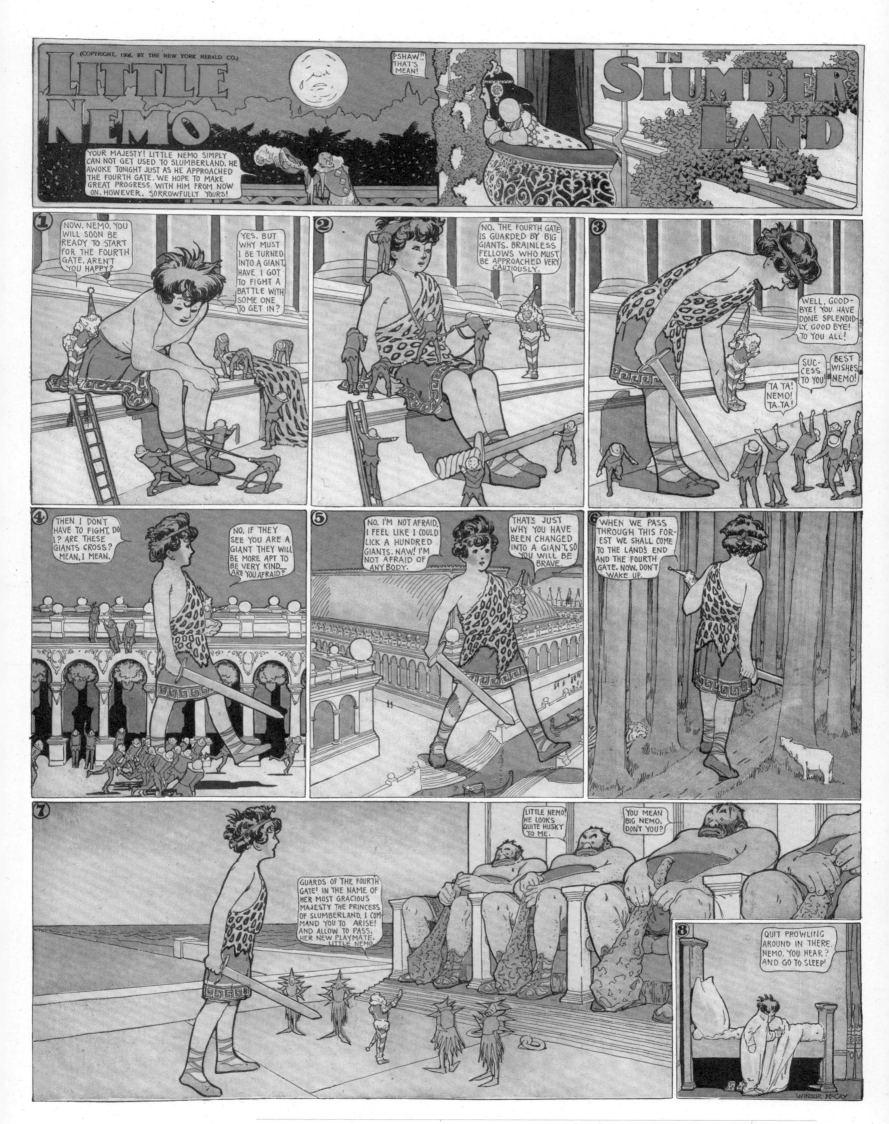

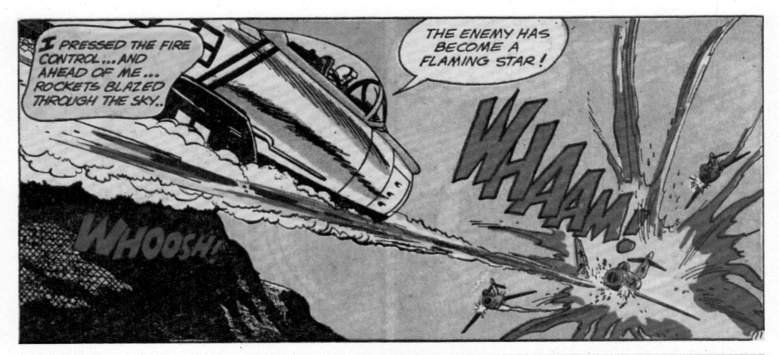

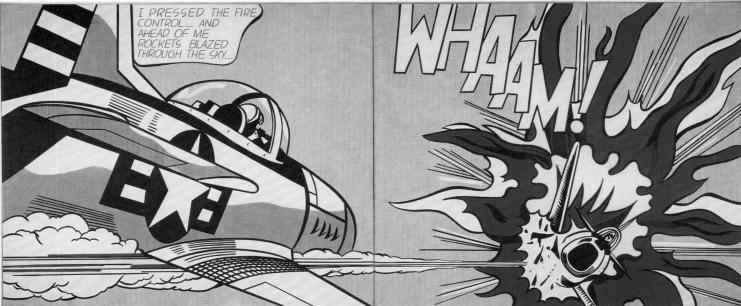

critics, however, his canvas-painted blow-ups monumentalised these tiny samples of what were perceived, by non-readers, as naive, impersonal hackwork into irony-laden icons. But if it wasn't for comics, one wonders how different Lichtenstein's oeuvre and the whole Pop Art movement might have been.

What annoyed the creators and admirers of the 12-cent, four-colour pamphlets about war and romance were the fame and wealth such derivative paintings brought and the lack of acknowledgement or appreciation of their sources. David Barsalou's Deconstructing Lichtenstein website allows you to see the changes Lichtenstein's versions made to the printed extracts.[8] In most cases, he considerably depersonalised their assorted line-work and shading and reduced or removed details and nuances to standardise his cleaner, smoother, and often heavier, flatter reinterpretations. To most gallery viewers this was of course how all comics looked. Seeing Barsalou's line-up of paintings and sources side-by-side makes you evaluate the artistry of each comic book original afresh, as one of dozens of panels from a whole story to which a skilled editor, writer, artist, letterer and colourist all contributed. So, for example, the Tate's famous purchase 'WHAAM!' is the 55th in a 65-panel, 13-page story 'The Star Jockey' from ALL-AMERICAN MEN OF WAR, No. 89 (February 1962), edited and possibly written by Robert Kanigher and drawn by Irv Novick.[9] Like a retouched still from a movie, the painting is but a glimpse of a fuller story-world. In fact, the protagonist behind the trigger is a Native American flying ace named Lt. Johnny Cloud, who privately finds that his boyhood belief in the prophetic powers of a Navajo elder's 'smoke pictures' saves him and his buddies from disaster.

Worlds away from Lichtenstein's mass-market combat heroes and sobbing girlfriends, there were other less clean-cut comics whose directness, energy and mixing of pictures and words would be central to several key American fine artists. Their works would come closer to being 'despicable enough' to ruffle art critics and inspire comics artists themselves. In 1966, broad-shouldered Chicago, the birthplace of a more earthy breed of Depression-era strips like LITTLE ORPHAN ANNIE and DICK TRACY, brought together the Chicago Imagists, notably H.C. Westermann, who studied advertising and design there from 1947, and six younger artists, among them Jim Nutt and Karl Wirsum, who formed the group The Hairy Who.

Their attitude towards fine art's loftiness is encapsulated in Westermann's ink and watercolour piece GREAT CULTURE EXPLOSION from 1966. Resembling a comic book cover, it channels all the stridency with which covers grab the eyeballs: poster-like punchiness, shrill, monumental letter forms, threateningly in three dimensions, an excess of subtitles, captions and asides filling every space, of symbols for mental turmoil such

ABOVE | 'The Star Jockey', ALL AMERICAN MEN OF WAR, No. 89, February 1962 ©1962 DC Comics. All Rights Reserved. Used with Permission.

CENTRE | Roy Lichtenstein, WHAAM!, 1963

BELOW | Chester Gould, DICK TRACY, 1950

as stars, swirls, exclamation points, and central to it all a frozen violent moment. On the roof of Le Corbusier's ravaged Villa Savoye in a litter-strewn compound he shows ART in capital letters being force-fed into the maw of an amorphous, limbless hominid, one eye crossed shut in pain, toppling like a ten-pin. 'Eat it baby!! Eat it raw', screams the speeding hand. A former US marine during the Second World War and Korean War, Westermann deflates the triumphalist logo with this scene of a bleak battle zone and mocks the art of the day as 'Anti-Individual' and 'international horseshit', rounding off with a large, contemptuous 'PHOOEY' at the foot of the drawing.

In contrast to most Pop Artists, the Chicago Imagists took no ironic stance towards comics and other populist art that inspired them. Instead, The Hairy Who celebrated them, going so far as to produce four comic books, some in full colour, which doubled as exhibition catalogues and displaying cases of comics and toys alongside their work. Narrative was never a priority. They found in the comics they loved the same raw, honest directness that could be found in their other influences, such as ethnic, naive and Outsider art. Consequently, their visionary work helped inject those same influences into the emerging underground comics themselves through such rebels as Rory Hayes, Gary Panter, Mark Beyer, Lynda Barry, Savage Pencil and Bruno Richard to recent groupings like Fort Thunder, Paper Rad, Kramers Ergot and Le Gun.

Westermann's imitation cover and The Hairy Who catalogues overlapped with the real underground comix also emerging in America's tumultuous late 1960s. On their mostly black and white newsprint inside their glossy colour covers, artists could finally cut loose on stories about uninhibited personal, political, satirical and sexual themes. At the time, there was a coming together in San Francisco of a creative counterculture in music, writing, design and lifestyle, lower-priced housing and printing, alternative publishers and retail channels through headshops or psychedelic paraphernalia stores and a gathering generation of distinct talents. This ignited a true 'Great Culture Explosion' of radical cartooning. American comic books finally had an artist-driven avant-garde. Art Spiegelman recalled this heady period: 'It did feel like this must have been what the Cubists were going through. All the magic of being in Paris for the Post-Impressionist moment did feel somehow like being in San Francisco in the early Seventies.'[10] The underground opened new

paths being explored to this day, from Justin Green's uncompromising, confessional autobiography to Spiegelman's referential, formal experimentation, and is now being re-evaluated as one of the most significant and far-reaching art movements in late twentieth century America.

If anything, comix artists in this period were more in synch with, or even anticipating, some of the most cutting-edge figures in fine art, without always being aware of each other. Around the time of Robert Crumb's ZAP 1 in 1967, Philip Guston, an established abstract painter of the New York School, made an unexpected U-turn to produce vigorous paintings and drawings of cartoon-like figures and objects. Most art critics were flabbergasted by their gallery debut in 1970. Guston asserted, 'American abstract art is a lie, a sham, a cover-up for a poverty of spirit, a mask to mask the fear of revealing oneself ... it is laughable this lie. Anything but this.'[11] Guston retreated from the city to Woodstock and the company of writers and poets, with whom he collaborated on several Poem-Pictures, about which he wrote in 1975: 'Its strange form excites me in that it does make a new thing – a new image – words and images feeding off each other in unpredictable ways. Naturally, there is no "illus-

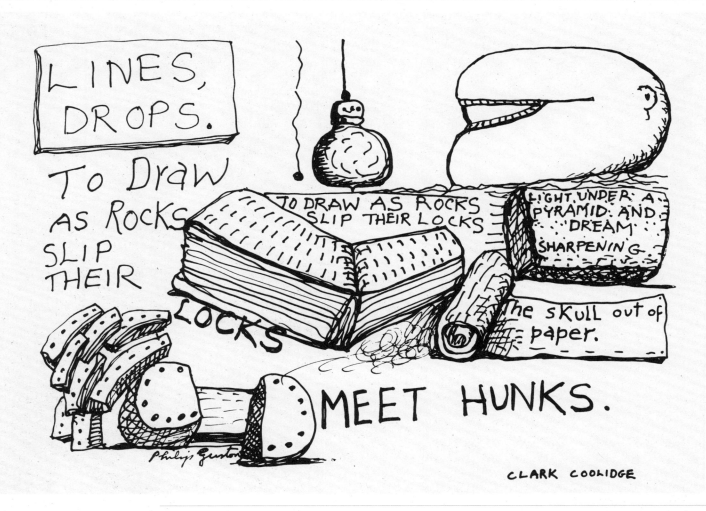

Les Coleman, NO, 1947 | ABOVE
Philip Guston and Clark Coolidge, LINES, DROPS, c. 1973 | BELOW
'We wanted to make the drawing space and the writing space simultaneous. We believe that it was anyway. No matter what we particularly did.' – Clark Coolidge regarding his collaboration with Philip Guston, quoted in Balken, D. B., 1994, PHILIP GUSTON'S POEM-PICTURES, The University of Washington Press, Seattle.

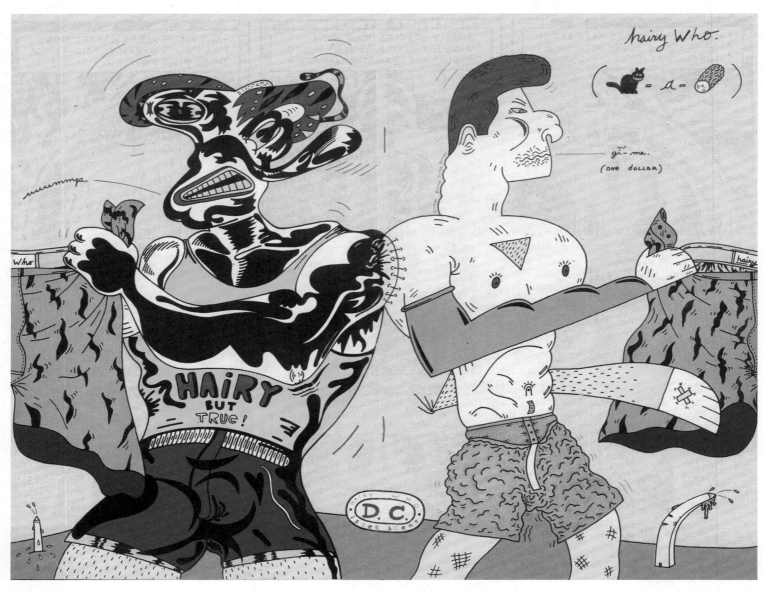

tration" of text, yet I am fascinated by how text and image bounce into and off each other... I think, hope, you'll agree that when it is all on one page, a more intimate & STRANGE situation is created...'[12] Guston's reputation is now greater than ever, built on his later work for which he was initially denounced, and his fascination with those visual and verbal 'situations' more widely shared.

Not every fine artist is as daring as Guston in making such a provocative shift. Many are encumbered by expectations to produce 'work to order', often in a previously known style, and to deadlines. Even so, opportunities to change directions and experiment were typically much rarer for comic artists until the underground. Publishers' prime concern was giving the public what they wanted. Considering the conservatism rife in the industry and its audience, comic artists managed a surprising amount of idiosyncratic expression.[13] Even so, their paymasters usually expected punctuality and speed, clarity and consistency, the same style every issue from start to finish, for ease of reproduction and readability. As for using different media, the cut-price print processes of most traditional comics precluded the use of oils, watercolours, pastels, collage or anything other than mainly strong outlines in black ink. Colour was secondary, like filling in the gaps on a stained-glass window, their palette limited to mechanical screen tones, often hand-cut by workshops of poorly paid women. The techniques behind some remarkable colouring effects achieved on America's early Sunday newspaper pages are all but lost today.

When the chance of full-colour printing arrived, initially for the children's market, both the RUPERT annuals and TINTIN albums opted for flat, ungraduated fields of colour. Fully painted comics had to wait for superior repro methods, such as Frank Hampson's utterly convincing photo-referenced future in DAN DARE from 1950 in EAGLE, or Harvey Kurtzman's and Will Elder's luxuriant sex-parody LITTLE ANNIE FANNY from 1962 in PLAYBOY. Varieties of colour and media, equivalent to

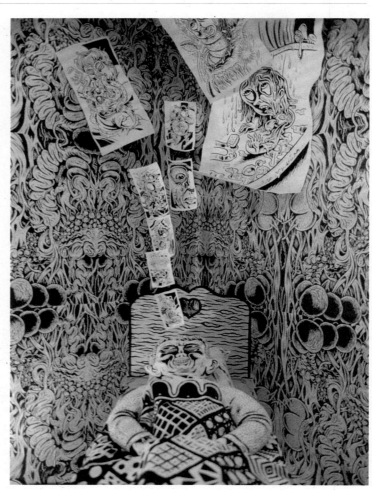

ABOVE Jim Falconer (left) and Jim Nutt (right), HAIRY WHO, 1969

BELOW Stéphane Blanquet, LE CHAMBRE (installation), 2004

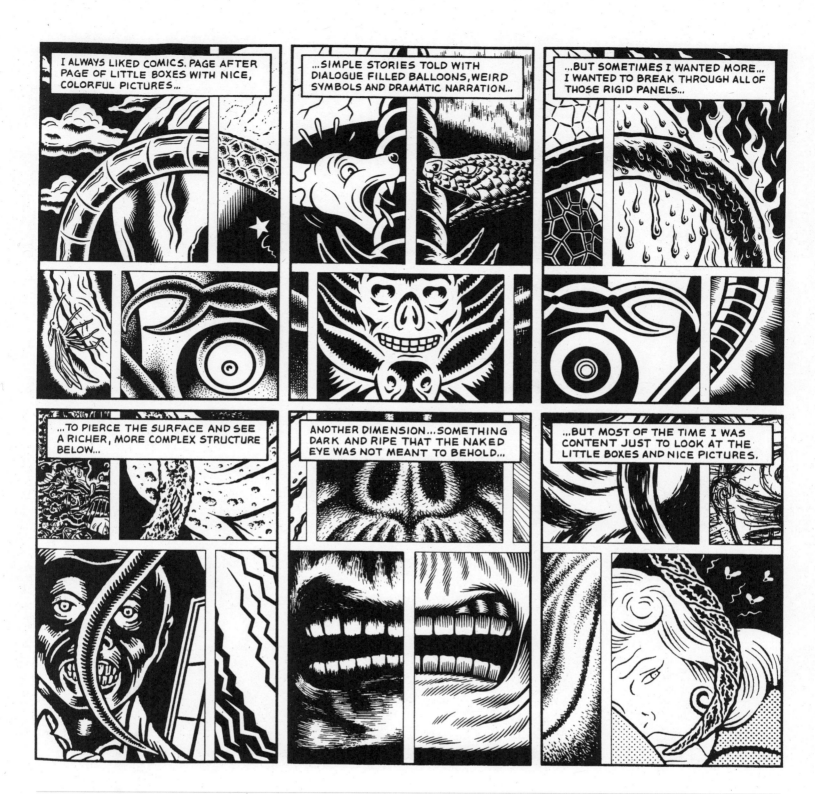

almost anything in illustration and painting, blossomed as never before in post-1968 French bandes dessinées for adults. All manner of approaches have since become widespread in graphic novels, including a return to the strengths and directness of drawing in black line, so that no single generic style can be said to define the 'look' of comics anymore and their artists no longer have to stick to one uniform artistic approach. LOST GIRLS is a prime example, in which Melinda Gebbie is able to refer as appropriate to various masters of erotic art and devise distinct visual vocabularies for each of her three heroines.

These recent shifts in what is possible in comics, from extended, intense, complex dramas to daring formal experiments, have coincided with a decline in the art world of the hegemony of painting and its emphasis on the individual, large and one-off work, and a renewed interest among artists in elements and properties found in comics: the energy of making multiple drawings, perhaps smaller, more immediate, with or without writing, and at times intended for reproduction and dissemination, not simply the gallery wall. Rather than merely appropriating pre-existing characters for ironic, iconic effect, current artists like Raymond Pettibon conceive a postmodern life for superheroes while enhancing their mythic resonance. The hegemony of story in comics is

Charles Burns, COMMEDIA DELL'ARTE, A project for ARTFORUM, 1991 | ABOVE

Colin Sacket, BLACK BOB, Coracle Press, London, 1989 | BELOW

also being challenged. Why should comics need to be thought of solely as strict linear narratives when they can be read and enjoyed as puzzles, patterns, poems, diagrams, storyboards, maps, artist's books, travelogues, reportage, sheet music, illuminated texts, instructions, art therapy, rituals, because both comics offer ways not only of building stories but of building intriguing, cumulative, multi-layered worlds. As both art and comics change, they seem to be becoming closer, crossing over or converging in their concerns. Art is now being made by comic artists, such as Julie Doucet's collages and prints, Charles Burns' photography, Killoffer and Blanquet's installations. Salvador Dalí, who also dabbled in comics himself, made the surreal prediction that 'Comics will be the culture of the year 3794.'[14]

Rather than happening in the far-distant future, perhaps it is happening all around us right now. Not just in art but in literature, cinema, gaming, the internet, comics are in the ascendancy and their language, history and properties being re-evaluated. As part of this, CULT FICTION's positioning, on equal terms, of current practitioners of comics and those of art informed by or related to comics demonstrates that both parties have much in common and much to learn and gain from one another. In truth, it seems they always have. Look again at H.M. Bateman's THE RUMOUR and Saul Steinberg's series of couples in conversation as inspiration for the communicative possibilities of the shapes of speech balloons and the typographic symbols for dialogue. Look at how Les Coleman finds a new use for the empty spaces between the panel borders, spelling out the word NO with them in a puzzle-like page of panels with no apparent reading order until clues between them surface. Look at how Colin Sacket in BLACK BOB (Coracle Press London 1989, edition of 100) repeats one spread of a BEANO panel of a dog and his master in the country

64 times, extending its presence and duration, denying us the chance to move on with the turn of a page but creating a frozen, contemplative state. Look at the urgent stream of 769 gouaches painted and written at the height of the Second World War by Charlotte Salomon, shortly before being sent to her death in Auschwitz, an autobiographical graphic novel before its time.

With open eyes and an open mind you will find that comics in whatever form of pictures and/or text they take will retain something of the 'intimate & STRANGE' which so enthused Philip Guston and which will continue to inspire artists and readers of all kinds.

Paul Gravett

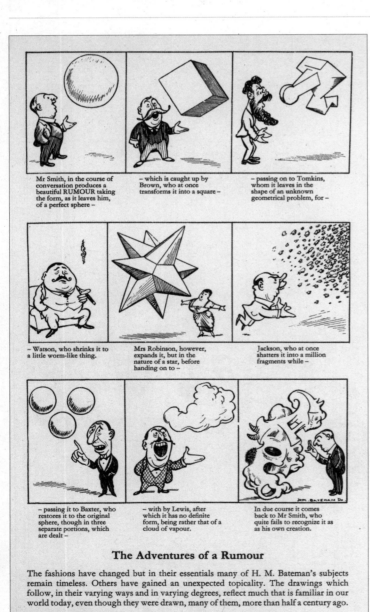

The Adventures of a Rumour

The fashions have changed but in their essentials many of H. M. Bateman's subjects remain timeless. Others have gained an unexpected topicality. The drawings which follow, in their varying ways and in varying degrees, reflect much that is familiar in our world today, even though they were drawn, many of them, more than half a century ago.

ENDNOTES

1. Will Eisner from 'The Spirit of the Spirit' by David Hajdu, *The New York Review of Books*, 21 June 2001
2. http://bugpowder.com/andy/index.html
3. From *Dangerous Drawings*, edited by Andrea Juno, Juno Books, New York, 1997
4. Adam Gopnik, 'The Genius of George Herriman', *The New York Review of Books*, No. 18, 18 December 1986.
5. This is the German pronunciation of *The Katzenjammer Kids*, a strip by Rudolf Dirks based on Wilhelm Busch's mischievous duo Max & Moritz. Katzenjammer, literally 'the howling of cats', is the German slang for a hangover.
6. 'Comic strips and cubism' by Jonathan Jones, *The Guardian*, 13 April 2002
7. Roy Lichtenstein, interview with John Coplans, *Roy Lichtenstein* (exh. cat.), Tate, London 1968
8. http://davidbarsalou.homestead.com/LICHTENSTEINPROJECT.html
9. By curious coincidence Irv Novick had served in the same company as Lichtenstein during World War Two.
10. Art Spiegelman in *Rebel Visions* by Patrick Rosenkrantz, Fantagraphics Books, Seattle, Washington, 2003
11. Quoted in Musa Meyer, *Night Studio: A Memoir of Philip Guston*, Alfred A. Knopf, New York, 1988
12. Philip Guston, from a letter to Bill Berkson in *Philip Guston's Poem-Pictures* by Debra Bricker Balkan, Adison Gallery of American Art, Andover, MA, 1994
13. For little-known, eccentric examples from American newspaper strips and comic books see *Art Out of Time* by Dan Nadel, Abrams, New York, 2006
14. This quotation comes from *Les aventures de la BD* by Claude Moliterni, Philippe Mellot and Michel Denni, Découvertes, Gallimard, Paris, 1996
With thanks to Les Coleman for his invaluable advice on both texts and images.

ABOVE H.M. Bateman, THE RUMOUR, 1920

OPPOSITE George Herriman, 'The Brick and I', KRAZY KAT, 1938

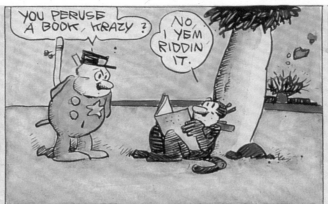

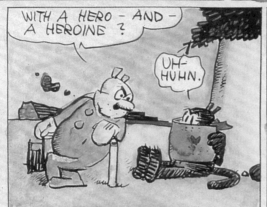

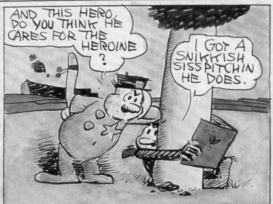

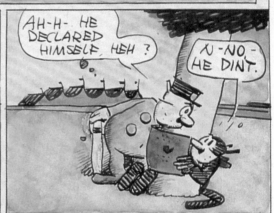

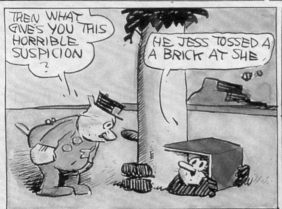

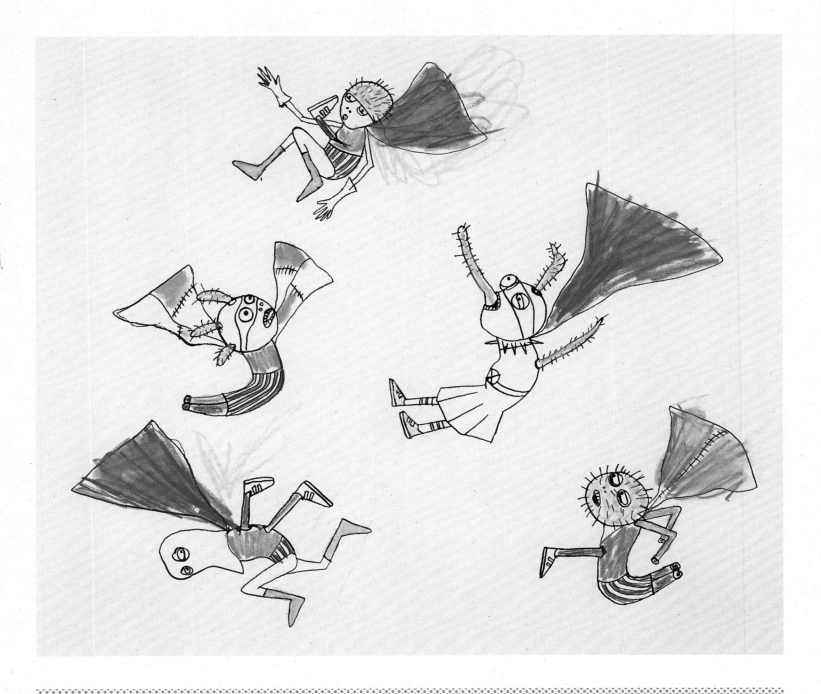

LAYLAH ALI

Born in Buffalo, New York in 1968, Laylah Ali studied at Washington University in St. Louis, Missouri, and Williams College, Williamstown, Massachusetts, where she continues to live. Her work, which mainly consists of small-scale gouache paintings, drawings and artist's books, includes the long running GREENHEAD series, chronicling the antics of green-headed tribes who appear to be trapped in an oppressive social order.

Laylah Ali's drawings depict a race of stylised humanoids embroiled in sometimes brutal interaction. Stick-thin characters, with androgynous torsos and large bowling balls for heads, engage in power struggles with uncertain outcomes. Presented as hermetic narratives, we are only party to the end results of what we presume to have been heated squabbles and violent encounters.

The caped superhero-like characters in her drawings seem to have no strategic purpose or heroic mission to fulfil. More like deformed misfits than superheroes, they fly around aimlessly in circles or grimace at each other in silent standoffs. Several of them bear disfigurements, such as hunched backs out of which tiny legs with sneaker-clad feet protrude. In one drawing a cascade of dismembered legs fall like missiles from the sky above two scowling characters in the apparent aftermath of a violent skirmish.

Ali casts her characters from the same mould, minimising distinguishing markers of race and gender, and forcing us to look for other signs, such as variations in dress and facial expressions, to differentiate between the aggressors and the oppressed. Some wear leotards, capes and masks – the apparel of superheroes – others are attired in what appear to be ecclesiastical vestments, and some are more simply dressed as servants or slaves. Often it is only the expressions on their oversized heads, a contortion of their denture-like teeth, or a look in their eyes that gives us any indication of who holds authority in the clan. Our only point of reference to suggest why these round-headed clones wage war on each other is in the human compulsion for the strong to tyrannise the weak.

Emma Mahony

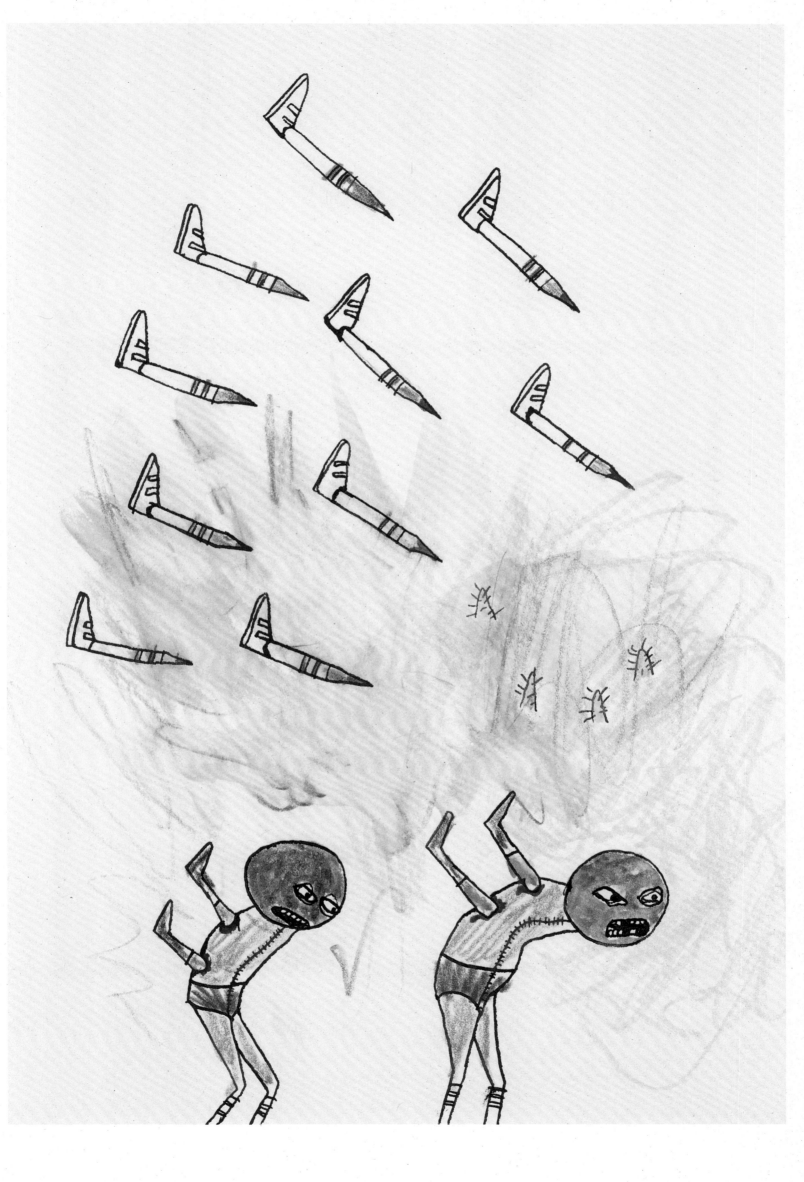

GLEN BAXTER

Glen Baxter was born in 1944 in Leeds, where he studied at the College of Art and discovered surrealism. 'After a brief period of chiaroscuro,' his website informs us, 'the young Baxter left his native home and set out on a makeshift sled, heading for London.' Having arrived, he taught at the Victoria and Albert Museum and lectured in fine art at Goldsmiths College. His work has appeared in many magazines and newspapers and he has produced numerous books, ranging from THE WORKS, a collection of his prose and drawings published in 1977, to THE UNHINGED WORLD OF GLEN BAXTER (2002) and LOOMINGS OVER THE SUET (2004). It should come as no surprise that Baxter, who made an early series of drawings depicting 'Great Culinary Disasters of Our Time', has a sandwich named after him in Pluckemin, New Jersey, or

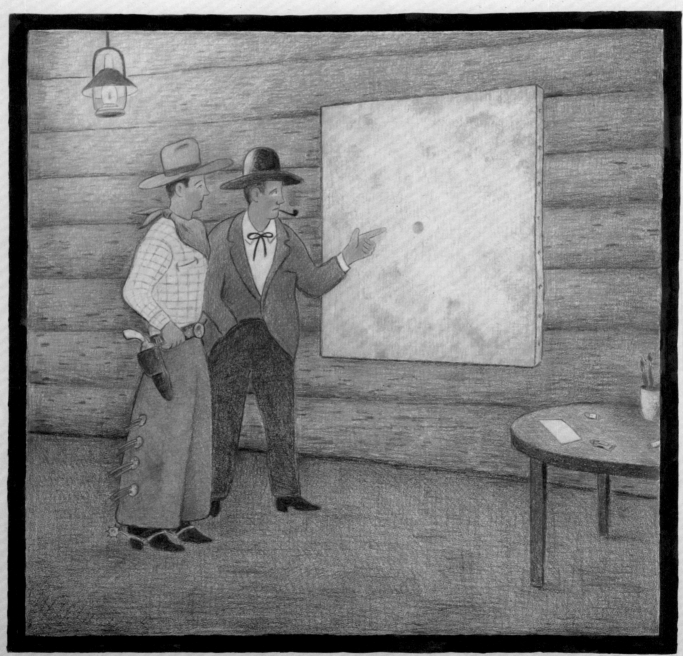

"LOOKS LIKE YOU'RE SLIPPING INEXORABLY INTO FIGURATION" DRAWLED THE EMINENT CRITIC

ABOVE | LOOKS LIKE YOU'RE SLIPPING INEXORABLY INTO FIGURATION, 2006

that he carries a business card announcing himself as 'Professor Glen Baxter. Marquetry, Perversity & Irony'.

Described in the NEW YORK TIMES as 'a kind of mad cross between Magritte, S.J. Perelman and pulp fiction', Glen Baxter has created an absurd world inhabited by schoolchildren, explorers, inventors, desperadoes and cowboys whose exploits include strange encounters with vegetables, devising bizarre contraptions that might belong in a narrative by the French surrealist Raymond Roussel, and the discussion of art and philosophy. Like single-frame comics, his image-and-caption works take what he describes as a 'deadpan Buster Keaton kind of approach', and combine BOY'S OWN paper-type line drawings – often vibrantly crayoned – with language that is incongruously recondite.

The Wild West has formed a long-standing part of Baxter's mythology. 'As a child I was exposed to all those B cowboy movies, Gabby Hayes stomping around saying "it jes' don't look right," so all these figures from literature and film got locked in my brain. They are sort of ideal for carrying

the message because you're keying into a shared idea,' he says. His cowboys have been grappling with modern art for nearly thirty years, and still find the schism between abstraction and figurative art teasing and perplexing. Besides galloping through the history of Western art – 'Hank's tour of the Louvre usually lasted almost 18 minutes' – and spouting psychology – 'Mister … jes' keep your Jungian analysis to yo'self … you hear?', Baxter's cowboys get to grips with Rothko, Giacometti, Damien Hirst and French philosophers such as Derrida and Foucault.

Helen Luckett

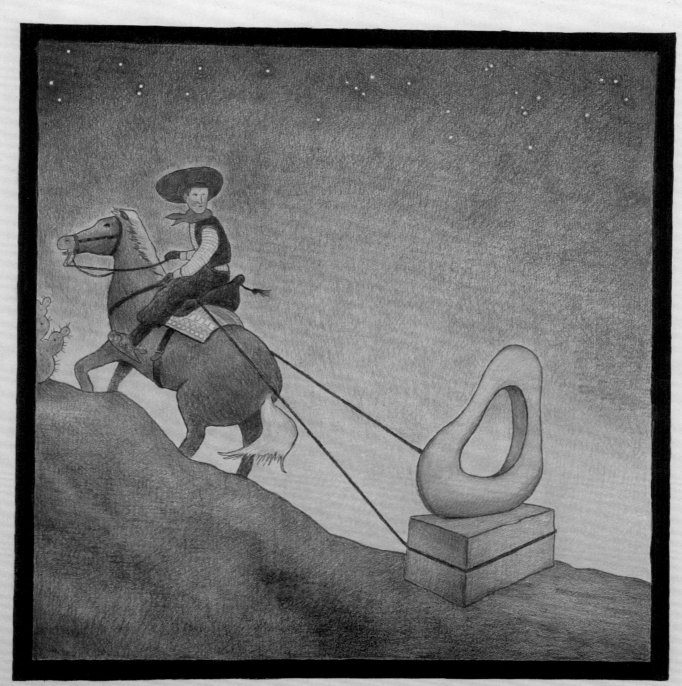

A SPATE OF HEPWORTH RUSTLING WAS SPREADING ALARM ALONG THE TEXAS BORDER

A SPATE OF HEPWORTH RUSTLING WAS SPREADING ALARM ALONG THE TEXAS BORDER, 2006 | ABOVE

STEPHANE BLANQUET

Born in 1973 in Conflans-Sainte-Honorine, France, Stéphane Blanquet developed a voracious appetite for the bizarre and extreme in both the popular and fine arts and founded his own publishing company Chacal Puant 'Stinking Jackal' at the age of 16. The macabre, grotesque world of his comics grew out of his fascination with the work of R. Crumb, Roland Topor, Hieronymus Bosch and the Surrealists, among others. In 1996, he won the prestigious Angoulême Festival fanzine award with his anthology LA MONSTRUEUSE 'THE MONSTROUS WOMAN'. While comics remain an important outlet for him – he is published by L'Association, Cornélius, Le Dernier Cri and other French independents as well as Fantagraphics in the USA – since 1997 he has branched out into animated films, made with coloured drawings which he joins together, and silhouettes cut from black paper. He has applied this 'shadow puppet' technique to several comic strips told without words, reinvigorating this graphic tradition.

For several years Blanquet has been confined to a wheelchair due to worsening spinal muscular atrophy. He refers to his illness as a 'fierce dog'. 'Some people have a crab as a pet, others a flu. I have a dog. A dog that one day or another, when my back is turned, will manage to gobble me up and wolf me down without a second thought. In the meantime, she sits obediently at my feet.' His deteriorating condition contributes to many of the recurring themes in his work as well as adding a genuine urgency to his creative activities. As an intense, prolific artist, he has translated his visions into a variety of other media, including stuffed dolls and toys, silkscreen prints, gallery installations and paintings onto live female nudes, as well as illustrations for national magazines and newspapers in France.

'My universe always revolves around the body ... in my stories, in my characters' transformations, in their mutations, ill-treatments and whatever else ... The body comes back again and again ... I use it like modelling clay which I can stretch, make into a ball, sublimate or try to understand...' His disturbing narratives of physical dysfunction, decay and doomed desires are usually laced with a pitch-black humour, but can also achieve moments of tenderness. Often resembling dark, cautionary tales from nineteenth-century folklore, they form a personal, primeval self-mythology.

Paul Gravett

ABOVE & OPPOSITE | LA VÉNÉNEUSE AUX DEUX ÉPERONS, 2001

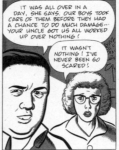
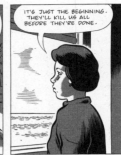

DAVID BORING

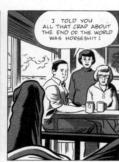

DANIEL CLOWES

Despite the fact that he has relocated to Berkeley, California, Daniel Clowes still sees Chicago's South Side – where he was born in 1961 and raised – as home. While a student at New York's Pratt Institute his teachers suggested that he should give up comics and try instead to make more 'conventional' forms of art, advice that he chose to ignore. Like his close friend and fellow Midwesterner, Chris Ware, Clowes takes suburban middle-America as his inspiration.

A pervading sense of sadness and failure hangs over 'Clowesland'. In his comic serial EIGHTBALL, a strange place peopled with 'ordinary, heroic misfits', characters like Lloyd Llewellyn, Enid and David Boring are loaded with repressed emotion, but their oddball personalities bring a surprising sense of humanity to their strange little worlds. Just as R. Crumb and the Hernandez Brothers spoke for their respective generations, EIGHTBALL captures a certain slacker zeitgeist, including stories such as his surreal LIKE A VELVET GLOVE CAST IN IRON – his first long narrative – and the later, more famous, GHOST WORLD (turned into a movie by CRUMB director, Terry Zwigoff in 2001).

In the existential world of David Boring his pursuit of romance is complicated by a murder mystery and terrorism. Boring is obsessed with trying to find the 'perfect woman', a quest which drives him to distraction, gun fights, and finally the end-of-the-world. Essentially it is an account of someone trying to come to terms with themselves. Speaking of the genesis for DAVID BORING Clowes explains: 'I was actually trying to create a character thinking, what if I had a kid? What if I had a son and he turned out to be like these horrible kids in Berkeley that I see every day – these pot-smoking and skateboarding guys who listen to bad music? I started thinking, God, I'd be so embarrassed! That would really be painful for me. I thought, what kind of son would I like to have? Who would be a guy I would actually like?'

Sherman Sam

I'VE BEEN LIVING WITH NAOMI SINCE MARCH. SHE'S HAD A VERY POSITIVE INFLUENCE ON ME. I'M A VEGETARIAN NOW. MORE AND MORE, I CAN'T STAND TO HURT ANY LIVING CREATURE. I'M TOO FEARFUL OF REVENGE.

I ACTUALLY DON'T THINK ABOUT WANDA THAT MUCH AT ALL ANYMORE. I'M TRYING TO GET AWAY FROM THAT SORT OF SHALLOW BEHAVIOR.

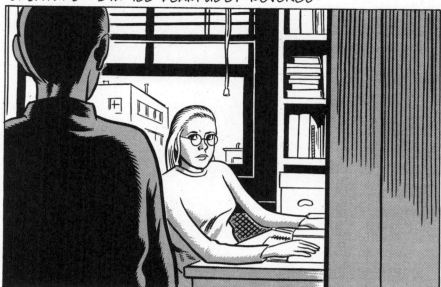

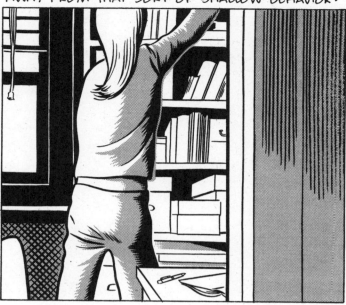

I'VE DECIDED TO WRITE A SCREEN-PLAY. I NEED TO DO SOMETHING TO VALIDATE MY EXISTENCE.

I INTEND TO FOLLOW ALL THE "RULES" OF SCREENWRITING (3-ACT STRUCTURE, ETC.). THERE'S NO POINT IN WRITING IT IF NO ONE WILL EVER SEE IT.

TO MAKE A MOVIE IS, FOR BETTER OR WORSE, TO ENTER AND PARTI-CIPATE IN THE SHAPING OF THE GENERAL UNCONSCIOUS...

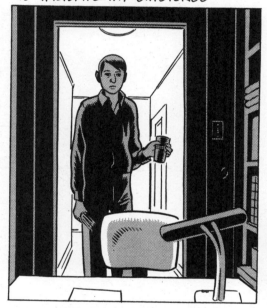

THE YELLOW STREAK ANNUAL HAS AT THIS POINT BEEN REDUCED TO AN ENVELOPE OF DISEMBODIED FRAMES: 9 OR 10 WATERLOGGED SURVIVORS...

DON'T YOU UNDERSTAND, FLORENCE?! I **HAVE** TO KILL YOU!

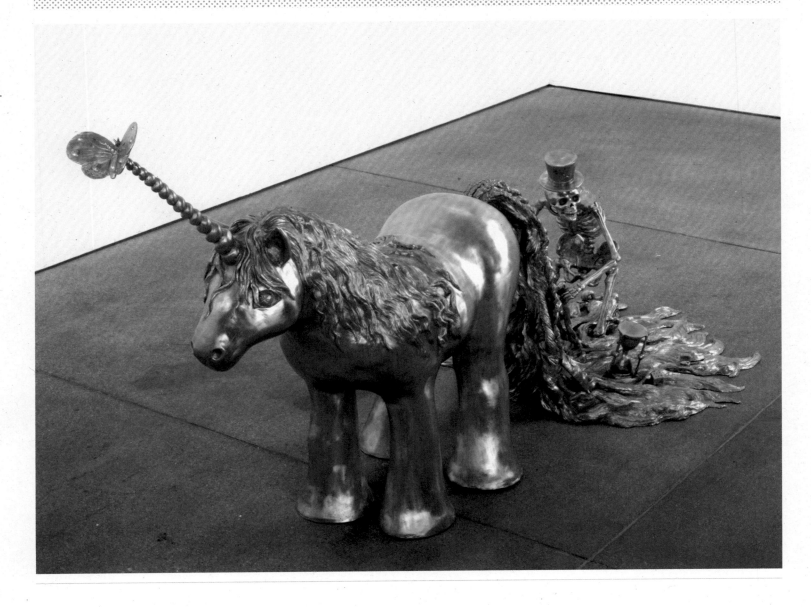

Born in 1970 and raised in Mammoth, a Californian ski resort, Liz Craft attended local colleges, graduating from Otis College of Art and Design before going on to study at the University of California. Still living in the sprawling conurbation of Los Angeles, Craft draws inspiration from her surroundings. Like the city in which she lives, her work '... is disjointed but comes together in a dream-like way'.

In a city whose history barely extends beyond a century, relics of the recent past have a special cultural significance. Liz Craft mines the junk stores, flea markets and garage sales of the Californian outposts of Santa Monica, Venice Beach and Woodstock for kitsch memorabilia of America's counter-cultural past. Relics of the hippies, Hell's Angels and psychedelia are lovingly recreated in bronze. Sculptures of choppers, pot-smoking hippies, mermaids and cacti contrast the monumental and almost indestructible qualities of the medium with the ephemeral, mass-produced effigies she replicates.

MY PONY evokes a scene from a non-existent fairy tale (of the Brothers Grimm variety) in which a macabre top hat-wearing skeleton plaits the tail of a unicorn. The unicorn resembles a vastly overblown replica of a child's 'My Little Pony' toy – itself a relic of Craft's childhood. Carefully positioned on the pony's tail is an array of objects: a theatrical mask, dice, a pair of scissors and an hourglass. They appear to act as interpretative clues to the hermetic narrative suggested by Craft's sculptural tableaux. A mythological creature, which can only be seen and touched by virgins, the unicorn is a symbol of purity, innocence and immortality, while the skeleton, surrounded by symbols of the passage of time, death and chance, represents the opposite. Craft's work is concerned with resurrecting these fleeting moments and one-time icons from the dustbin of cultural history and imbuing them with a gravitas that is arguably in excess of their cultural value. By including references to death and the passage of time, as she does in MY PONY, she reminds us that although her work seeks to immortalise these 'transient moments', they are nevertheless just that: everything has a limited life span.

Emma Mahony

ABOVE THE PONY, 2004
OPPOSITE HAIRY GUY (BALLERINA), 2005

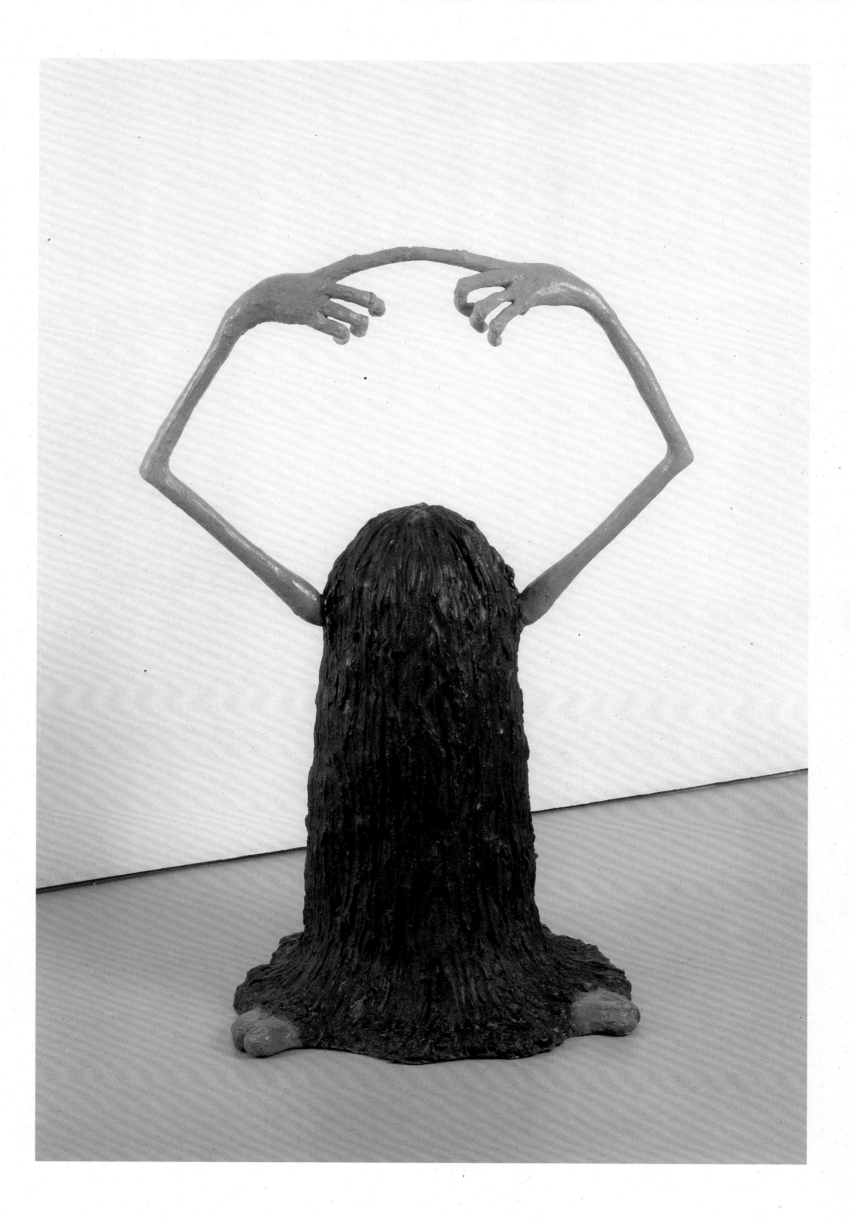

AMERICAN SPLENDOR ASSAULTS THE MEDIA

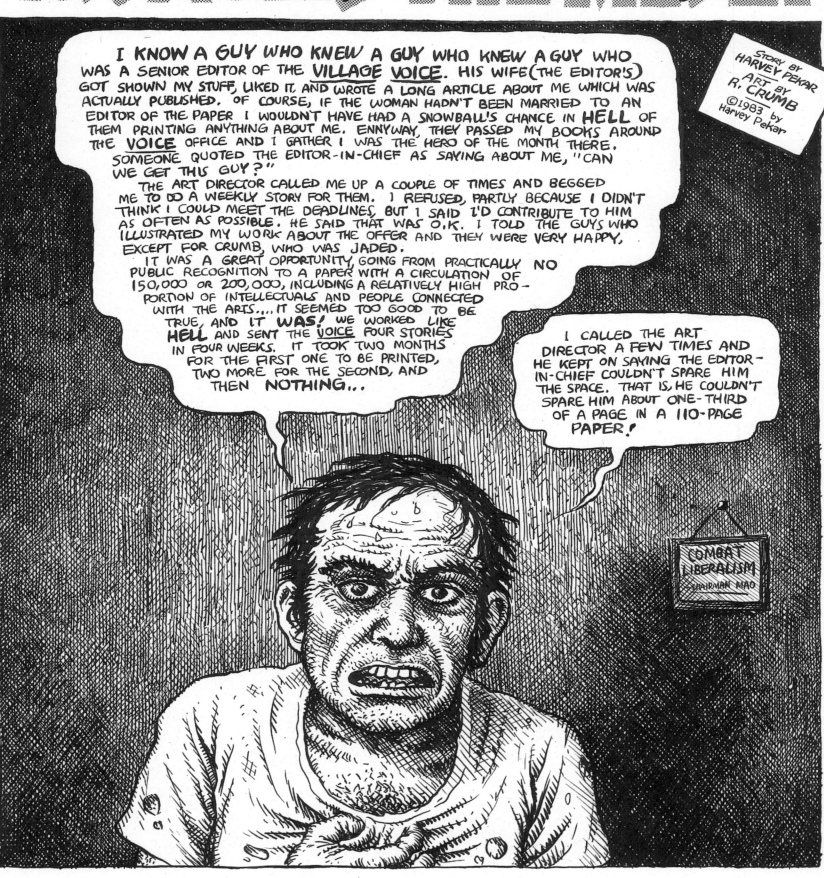

STORY BY HARVEY PEKAR
ART BY R. CRUMB
©1983 by Harvey Pekar

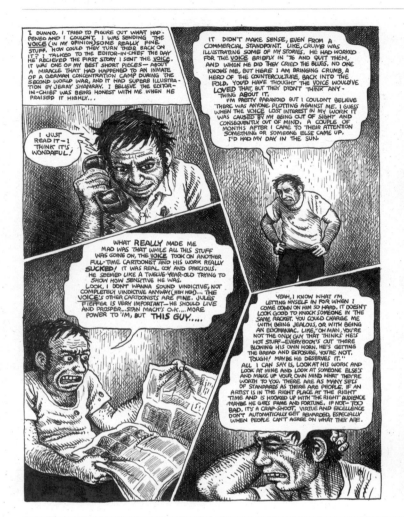

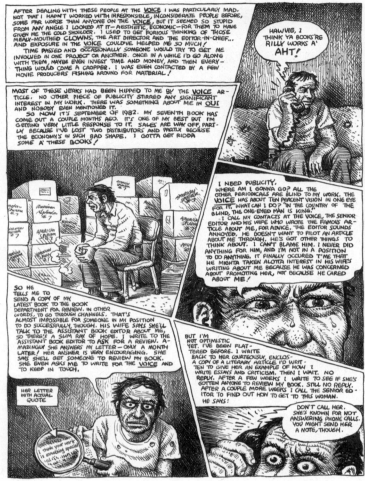

R. Crumb is the presiding genius of underground comix, a genre with which he continues to be associated four decades after he distributed the first issue of ZAP COMIX around San Francisco's Haight-Ashbury. His down-at-heel cynical realism, caustic humour, self-mockery and outrageous sexual imagination helped to define the era, which he ridiculed for its delusions and narcissism. Crumb started out in Cleveland, Ohio, drawing greetings cards, and it was there in the mid-1960s that he met Harvey Pekar, with whom he shared an enthusiasm for jazz records. In 1967, after seeing the light on LSD, travelling in Europe and a spell in New York, he moved to San Francisco, where his comics creations such as MR. NATURAL and FRITZ THE CAT quickly acquired a cult following. Since 1990 Crumb has lived in southern France with his fellow cartoonists, wife Aline Kominsky and daughter Sophie.

Crumb is now an artistic institution, with retrospectives in such galleries as the Ludwig Museum in Cologne and the Whitechapel in London. The critic Robert Hughes has described him as the Breughel of the late twentieth-century. Crumb resists the comparison, which 'would reveal all the weaknesses in my work. That guy could draw like God.' But he certainly identifies most with Breughel and Bosch, and the 'history of popular art that the general art world knows nothing about … lurid, crude and raw.'

The comics writer Harvey Pekar launched the autobiographical comic AMERICAN SPLENDOR in 1976, collaborating with Crumb and other cartoonists on stories of his mundane life and times in Cleveland, where he worked as a file clerk in the Veterans Administration Hospital. The existential anti-hero, his colleagues and friends share a 'working man's outlook on life', and

Pekar consoles himself that if he gave up the day job and became a full-time writer, he would be 'out of the struggle, sort of in an ivory tower watching the mainstream of life go by rather than participating in it … I'd be alienated but I wouldn't think I had the right to feel bad about it. I mean, I'd be a well-paid, famous author. What right would I have to complain about anything?' IN AMERICAN SPLENDOR ASSAULTS THE MEDIA, Harvey finds plenty to complain about in his mistreatment by the VILLAGE VOICE. In his rant against the editors for not printing his work or reviewing his books, the soliloquy, hand-written by Crumb in speech bubbles, overwhelms the drawings of the fuming little man. 'I was gonna write this jive woman [the assistant book editor who promises things because she wants to seem agreeable but doesn't keep her promises because it's too much trouble] a nasty letter, but a guy at work talked me out of it … so I sublimated by writing this story … That's about all I can do when things bother me – write stories about them.'

Roger Malbert

AMERICAN SPLENDOR ASSAULTS THE MEDIA, 1983 | ABOVE & OPPOSITE

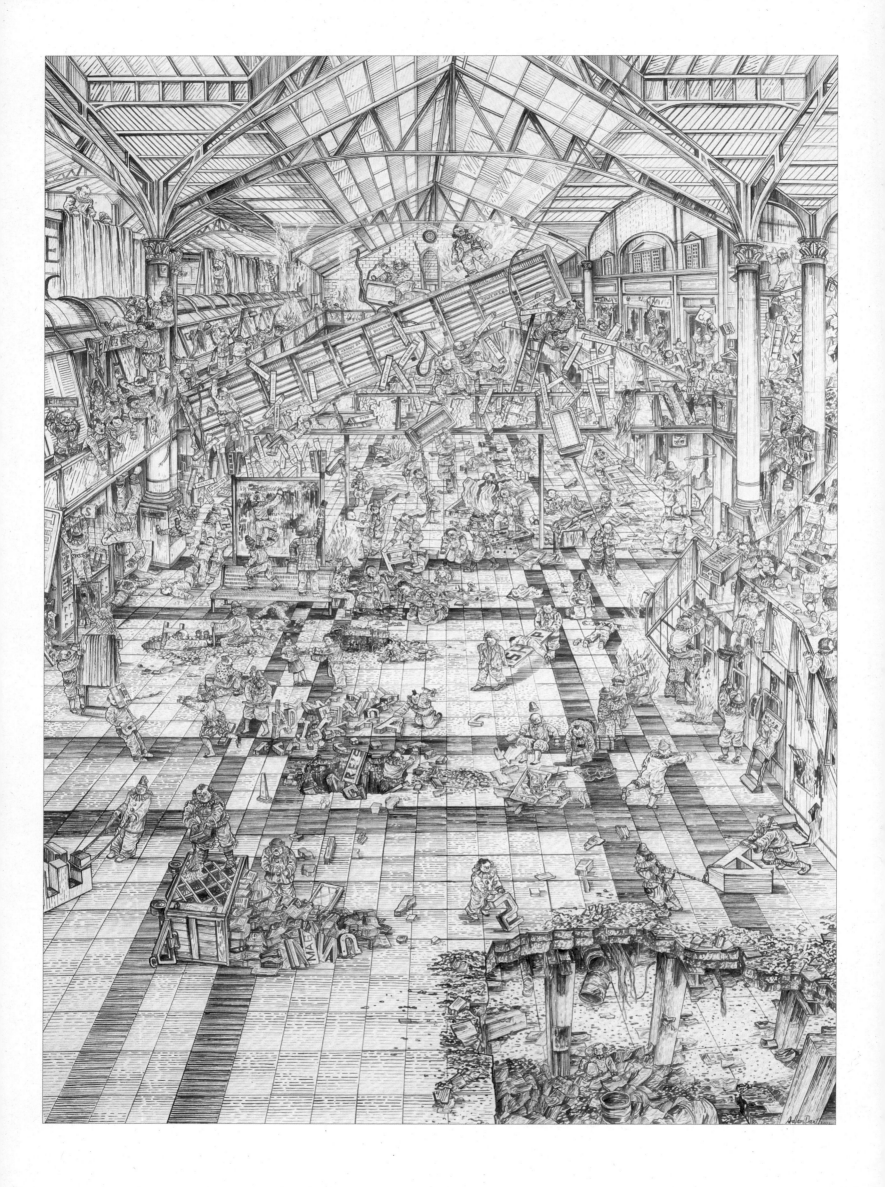

ARTIST, Adam Dant | CULT FICTION | 39

Born in Cambridge in 1967, Adam Dant went north to study graphic design at Liverpool School of Art. Exposure to printmaking techniques in India then prompted him to study printmaking at the Royal College of Art. London's East End has provided the inspiration for much of his work and he currently lives and works in Shoreditch.

Dant's pen and ink drawings are detailed meanderings on his geographical, political and social surroundings. Interested in mapping systems, his work satirises familiar social and architectural structures. Every day for five years from 1995, Dant produced a diary in the guise of his alter ego, fictitious funny-man, Donald Parsnips. Chronicled on a folded sheet of A4 paper, which he photocopied between 50 to 100 times, Dant gave the journal to unsuspecting passers-by, in order to inspire them with his pocket-sized ruminations. Originally created in Paris, DONALD PARSNIPS DAILY JOURNAL has been produced in many languages. Parsnips has shared his daily observations, questions, comic strips and instructions on modern life in words, doodles and collages in English, German, Italian and Arabic, depending on where he was at the time. Intent on communicating directly with the locals, his pamphlet was executed in a style and materials dictated by the circumstances of its production, the most arduous edition being the multiple copies penned on papyrus in Egypt. Like a seventeenth-century pamphleteer, Dant spoofed the contents of popular publications to create his own journal, infiltrating society with his idiosyncratic humour.

Dant's elaborate large-scale drawings depict unusual goings-on in familiar settings. In NON-VERBAL COMMUNICATION a group of clowns wreak havoc in Liverpool Street Station. These Goya-esque comic characters, who commonly mime and gesture rather than use speech, destroy the signposts in this public terminus. Passing commuters are knocked from their paths by clowns dragging giant letters across the floor, and broken signs fall from the vaulted ceiling. As the station collapses at the hands of these dissident figures, the viewer is left to wonder what new regime will replace the destroyed signage. Will commuters be forced to adopt 'non-verbal communication', as the title suggests?

Alice Lobb

JULIE DOUCET

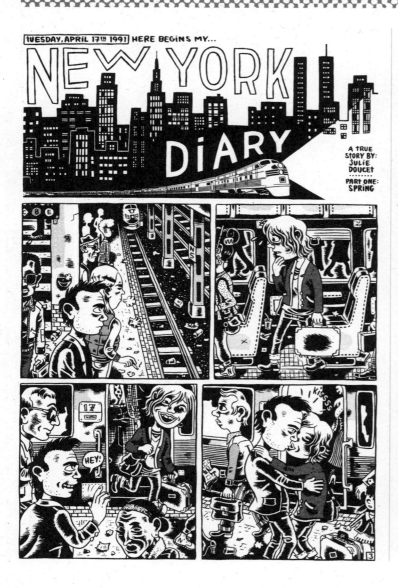

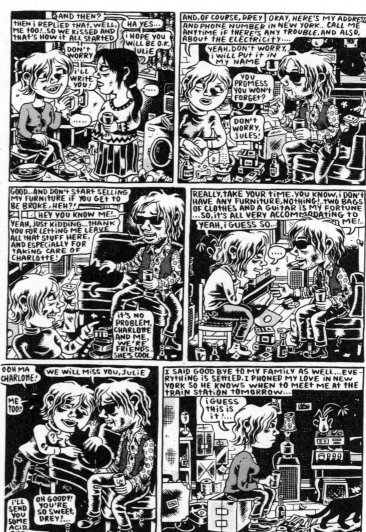

Born in 1965 in Montreal, Julie Doucet was educated at Catholic School. Her first comic book series, DIRTY PLOTTE, began life as a photocopied mini-comic while she was at art college in Montreal. Its title translates as the French word for 'cunt', and the comic documents her dreams, diaries and stories, creating an autobiographical work that would make most of her teachers squirm. The series was first published in 1990 by DRAWN AND QUARTERLY and shortly afterwards she won the prestigious Harvey Award. She left for New York, where she spent a year recalled in MY NEW YORK DIARY, and then moved to Seattle where her first collection of comic strips was printed as LIFT YOUR LEG, MY FISH IS DEAD!. From 1995 she spent three years in Berlin, during which time DRAWN AND QUARTERLY published her second set of strips as MY MOST SECRET. Returning to Montreal in the late 1990s, she abandoned the medium of comic books and embarked on LONG TERM RELATIONSHIP, a series of non-narrative engravings which was published in 2001.

Julie's work is an honest and uncensored tangle of autobiographical tales that map her most intimate moments, from losing her virginity and tripping on LSD to details of her strangely familiar dreams and nightmares. MY NEW YORK DIARY chronicles her experience in the city in 1991, where she moved to live with her fellow comic book artist boyfriend in Washington Heights. Both without day jobs, they spend most of their time in the flat; and evenings of indulging in beer and drugs quickly take their toll, increasing Doucet's epileptic seizures and her feelings of isolation. Despite her despondency with the situation, described in calls to her Montreal friends, Doucet retains a steady stream of commissions from the New York comic book world while her (mostly unemployed) boyfriend grows increasingly jealous.

A master of drawing clutter and busy backgrounds, the mood of her stories is evoked by the personification of objects. The ornaments and bric-a-brac that occupy her new home greet her with smiles when she arrives and frown at the couple's many heated arguments. Documenting the end of the relationship and her eventual departure from New York, MY NEW YORK DIARY also records Doucet's personal life experiences in a style that elicits humour rather than concern.

Alice Lobb

ABOVE & OPPOSITE | MY NEW YORK DIARY, 1999

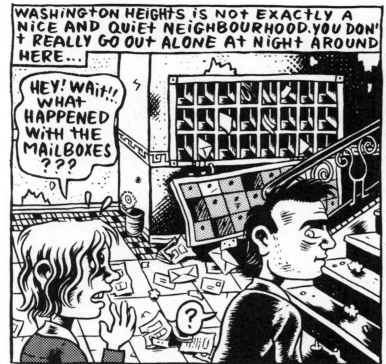

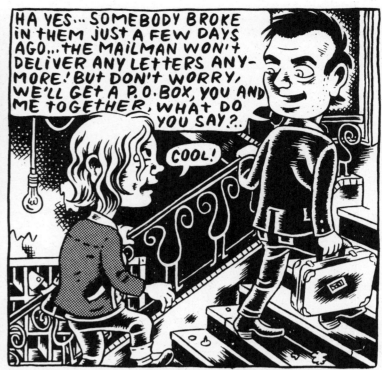

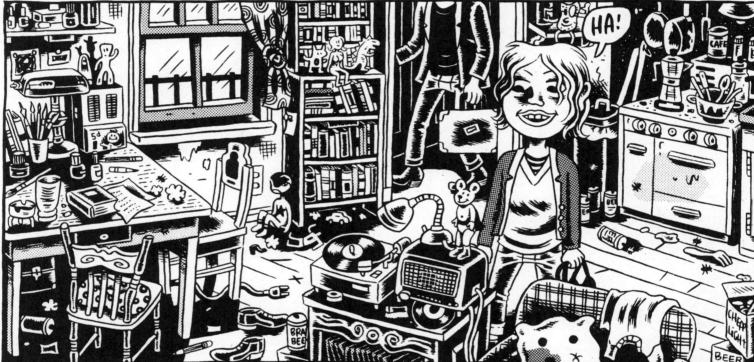

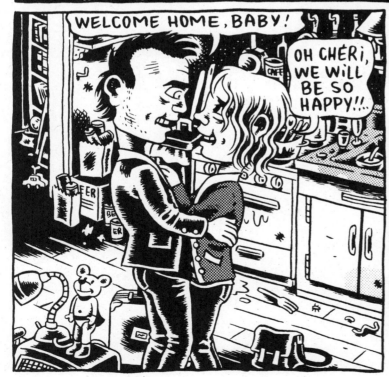

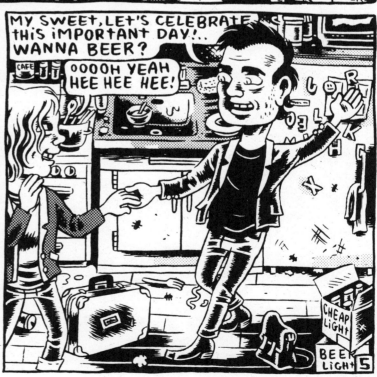

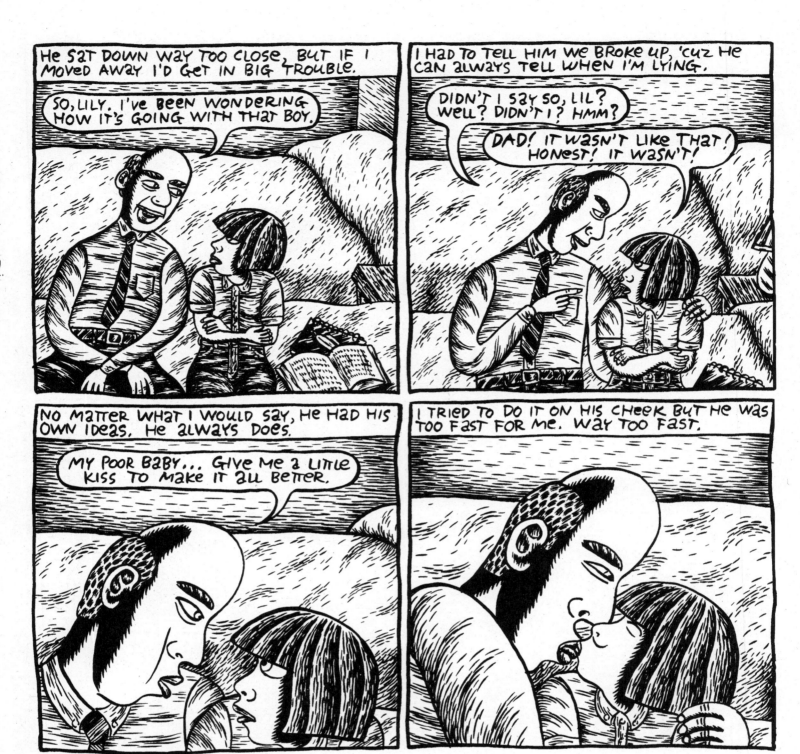

DEBBIE DRECHSLER

Born in 1953 in Champaign, Illinois, but now based in northern California, Debbie Drechsler turned to superhero comics and MAD magazine as a distraction from the frequent uprooting she experienced as a child. After studying graphic design at Rochester Institute of Technology, New York, she found work as an illustrator, which she continues today. It was only when she discovered alternative comics that she found the perfect medium to express herself. Instead of superheroes, it was the work of Lynda Barry, the comics artist – who mainly told stories from the point of view of adolescent girls and draws ERNIE POOK'S COMEEK – that proved inspirational.

Drechsler's first comic was published in TWISTED SISTERS in the early 1990s, but her career was launched with a regular series in the alternative weekly newspapers NEW YORK PRESS and THE STRANGER. Eventually collected under the title DADDY'S GIRL, it relates the artist's own personal story, a controversial and heartbreaking tale of a girl being abused by her father. Speaking about her history she has said: 'I had this material that I needed to get out of me, and at the same time I discovered comics, which perfectly suited it; doing paintings about incest wasn't going to cut it for me. Obviously, I couldn't put it in my illustrations.' DADDY'S GIRL tells her story from the perspective of her alter ego Lilly, first as a child, and later as a teenager. She has described herself during the process of drawing the comic as being in 'a trance-like state'. Hence, 'there isn't a lot of conscious decision-making. The story's there. It declares itself and how it wants to be written. I do some organizing, but to a large extent, it creates itself.'

Sherman Sam

ABOVE & OPPOSITE | TOO LATE, DADDY'S GIRL, 1995

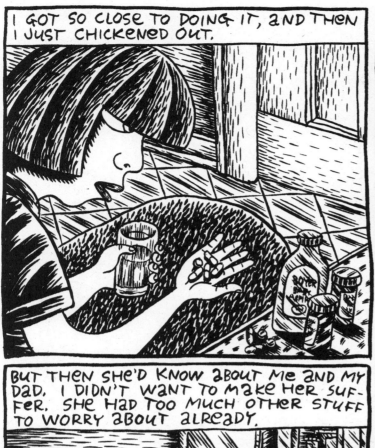

I GOT SO CLOSE TO DOING IT, AND THEN I JUST CHICKENED OUT.

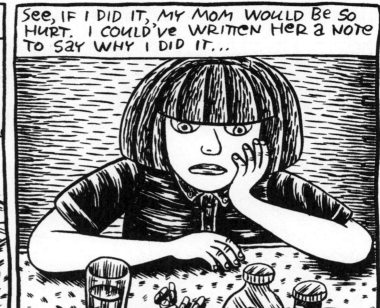

SEE, IF I DID IT, MY MOM WOULD BE SO HURT. I COULD'VE WRITTEN HER A NOTE TO SAY WHY I DID IT...

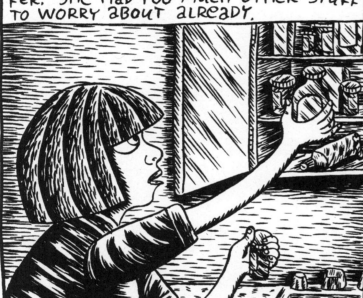

BUT THEN SHE'D KNOW ABOUT ME AND MY DAD. I DIDN'T WANT TO MAKE HER SUFFER. SHE HAD TOO MUCH OTHER STUFF TO WORRY ABOUT ALREADY.

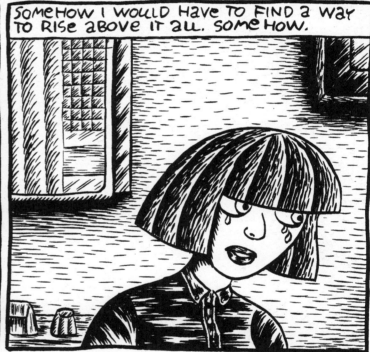

SOMEHOW I WOULD HAVE TO FIND A WAY TO RISE ABOVE IT ALL. SOMEHOW.

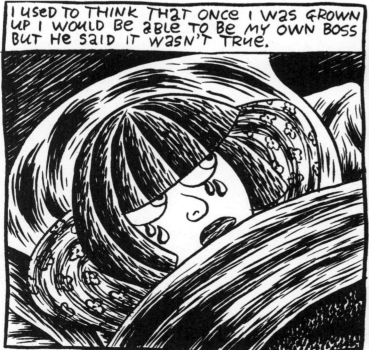

I USED TO THINK THAT ONCE I WAS GROWN UP I WOULD BE ABLE TO BE MY OWN BOSS BUT HE SAID IT WASN'T TRUE.

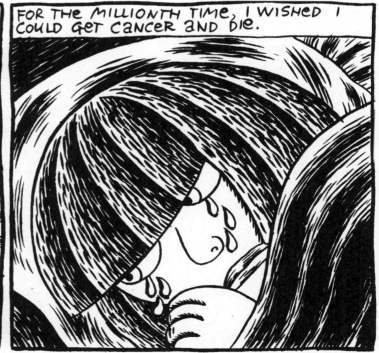

FOR THE MILLIONTH TIME, I WISHED I COULD GET CANCER AND DIE.

MARCEL DZAMA

Born in 1974 in Winnipeg, Marcel Dzama's work is testimony to what must have been an unusual Canadian childhood. At the age of 22 his home went up in flames, thankfully sparing all but the family pet, and the artist's now well-known, pared-down drawing style flowered from the confines of a small hotel room. At the same time he co-founded The Royal Art Lodge, an artists' collective made up of Dzama's closest friends and his 12 year-old sister Holly. He currently lives and works in New York City.

Dzama's ink and watercolour drawings depict a world where bats, bears, half-tree/half-human hybrids, knife-wielding women and armed men in uniform congregate to make both love and war. The always absurd, often violent and occasionally lewd scenarios played out by his wacky cast of characters meld a childlike imagination with adult fantasy, by drawing upon a slew of cultural references from Dante and Freud to CAPTAIN AMERICA and Inuit art. His ideal audience is his friends and relatives, which partly explains the very personal and improvisational nature of his compositions and technique.

Dzama's outlined figures float on otherwise blank, manila-coloured paper, fleshed out with his signature palette of muted reds, blues, yellows, greys and brown tones (which are made from concentrated root beer). Never touching the edges of the page, Dzama's ambiguous vignettes are suspended in space in much the same way as his narratives are suspended in time. Despite the serial-like repetition of characters and situations, there is no sequential relationship between one image and the next. The viewer is left to muse upon possible permutations and connections. Are the line-dancing human-animal hybrids in one drawing the offspring of the bestiality that takes place in another? Is a mother's rifle lesson in one image responsible for the violent actions of the baby girl who decapitates a weasel elsewhere? Dzama's drawings are as perplexing as they are disturbing and the connections we make to form the narrative draw us further into his darkly humorous world.

Oriana Fox

ABOVE | UNTITLED (DETAIL), 2006

MELINDA GEBBIE
IN COLLABORATION WITH ALAN MOORE

Born and raised in San Francisco, Melinda Gebbie first had her work published in WIMMEN'S COMIX – an alternative comic written and drawn by women. Her sexually-charged stories were also published in underground anthologies, TITS & CLITS, WET SATIN and ANARCHY, and in 1977 she completed her own comic book, FRESCA ZIZIS. She came to England in 1984 to work on the animated film version of Raymond Briggs' anti-nuclear graphic novel, WHEN THE WIND BLOWS, and continues to live and work in the UK. When invited to contribute an eight-page story to THE TALES OF SHANGRI-LA, she met writer Alan Moore, with whom she embarked on the longest and most enduring collaboration of her life, the co-creation of LOST GIRLS. This epic, erotic fairytale odyssey took them 16 years to complete. 'Within the first few weeks, we realised our ideal was going to take a long time. It wasn't productive in the beginning', says Moore. 'I couldn't think beyond a smutty parody, which is not what the world needs. Mel said that she liked working with three characters, and Alice, Wendy and Dorothy came into the picture.'

Set in a remote hotel on the Austrian border just before the outbreak of World War I, the 'lost girls' of the title are Alice, Dorothy and Wendy from ALICE IN WONDERLAND, THE WIZARD OF OZ and PETER PAN respectively, whom we now meet as young women. Related over the course of three volumes, LOST GIRLS recounts their early sexual experiences in the context of their storybook characters. Gebbie's colourful and soft-edged drawing style diffuses the explicitly sexual content of the story and reunites it with its children's book origins. Speaking of the impetus for their book, Moore has said: 'Certainly it seemed to us that sex, as a genre, was woefully under-represented in literature… We just kept talking about how poor the pornography field was and how little there was of any interest, and how the pornographic artwork by famous artists that we had seen had usually been left unsigned or sometimes hidden away or something. We just had the idea that there was a need for a project like this.'

A long-time anarchist, vegetarian and practitioner of magic, Alan Moore was born in Northampton in 1953. In collaboration with many illustrators and comics artists he has produced graphic novels that are remarkable for their complexity and sophistication and are deeply embedded in historical and literary research; V FOR VENDETTA with David Lloyd and FROM HELL with Eddie Campbell are notable examples.

Emma Mahony / Sherman Sam

MARK KALESNIKO

Born in 1958 in Trial, British Columbia, Mark Kalesniko attended the David Thompson University Centre in Nelson and is currently based in Glendale, California. Nelson, a very liberal town where hippies and draft dodgers had migrated in the late 1960s, was to become the inspiration for the town of Seven Mile in which his graphic novel MAIL ORDER BRIDE is set. Kalesniko studied animation at the California Institute of the Arts and immediately after graduating he went to work for Disney, where he was employed on and off for the next 15 years, working on such films as THE LITTLE MERMAID, MULAN and THE LION KING.

In part, it was the team effort of animation that led Kalesniko back to the more private activity of making comic books, which he enjoyed as a child. The basis of Alex – a recurring protagonist in Kalesniko's world – originated from a dog character he created as a child. Like Charles Bukowski, one of

his literary heroes, Kalesniko often sets his characters in confrontational and rather difficult situations, creating complex existential scenarios to which his protagonists are forced to respond. In MAIL ORDER BRIDE, the stereotypically docile Korean girl meets a Canadian comic book geek. Neither character is what the other expects. In describing the process that led to the development of the story, Kalesniko says: 'What one perceives is not what one experiences. People do not fit into this neat stereotypical package, be it a mail order bride or a comic book geek. Reality has a way of shaking up perceptions.' In Kalesniko's world, expectations in life lead to disappointment. His daunting stories explore how these setbacks are overcome.

Sherman Sam

MAIL ORDER BRIDE, 2001 | ABOVE & OPPOSITE

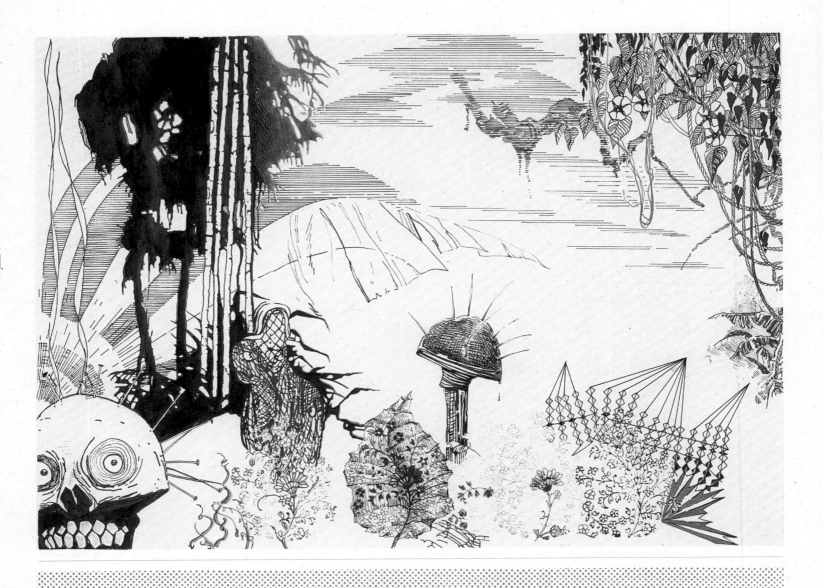

KERSTIN KARTSCHER

Kerstin Kartscher was born in Nuremberg, Germany, in 1966. She studied Fine Art, first in Nuremberg and then in Hamburg. Her early work, made while still a student, involved photography and video; she began to draw in 1998, using magic markers and fluorescent pens on paper and fabric. She has recently made large-scale installations, combining her drawings of imaginary places with assemblages of found objects.

'When ideas float in our mind without any reflection or regard of the understanding,' wrote the seventeenth-century philosopher John Locke, 'it is that which the French call "reverie".' Many of Kerstin Kartscher's drawings feature solitary women presiding over fantastic, alien landscapes. Are these images products of the waking or the sleeping mind? The title FLOW AND ARREST OF THOUGHTS suggests reverie, but the apocalyptic atmosphere and the strange disparity of objects in this work have the peculiar dislocation and elusiveness of dreams. The more one looks at the intricate drawing, with its calligraphic flourishes and its contrasts of white space and almost obsessively repetitive hatched lines, the more hallucinatory it appears.

Imaginary places are not subject to the same laws and dimensions as real life, and so the assemblage of gigantic chains, the blasted tree trunk with its colony of nesting boxes for small birds, the futuristic ski-jump structure and the tranquil guitar-plucking girl – a collaged figure who might perhaps have conjured up this whole scene – cannot be explained in terms of everyday logic. Though they do not convey any obvious symbolism and evade explanation, these landmarks contribute to a profound sense of melancholy.

Whilst elements in FLOW AND ARREST OF THOUGHTS recall the techniques and even the subjects of old engravings (Dürer and Gustave Doré come to mind), HAZARDOUS YOUTH, with its overtones of teenage angst and undertones of Eminem, portrays a futuristic gothic vision.

Helen Luckett

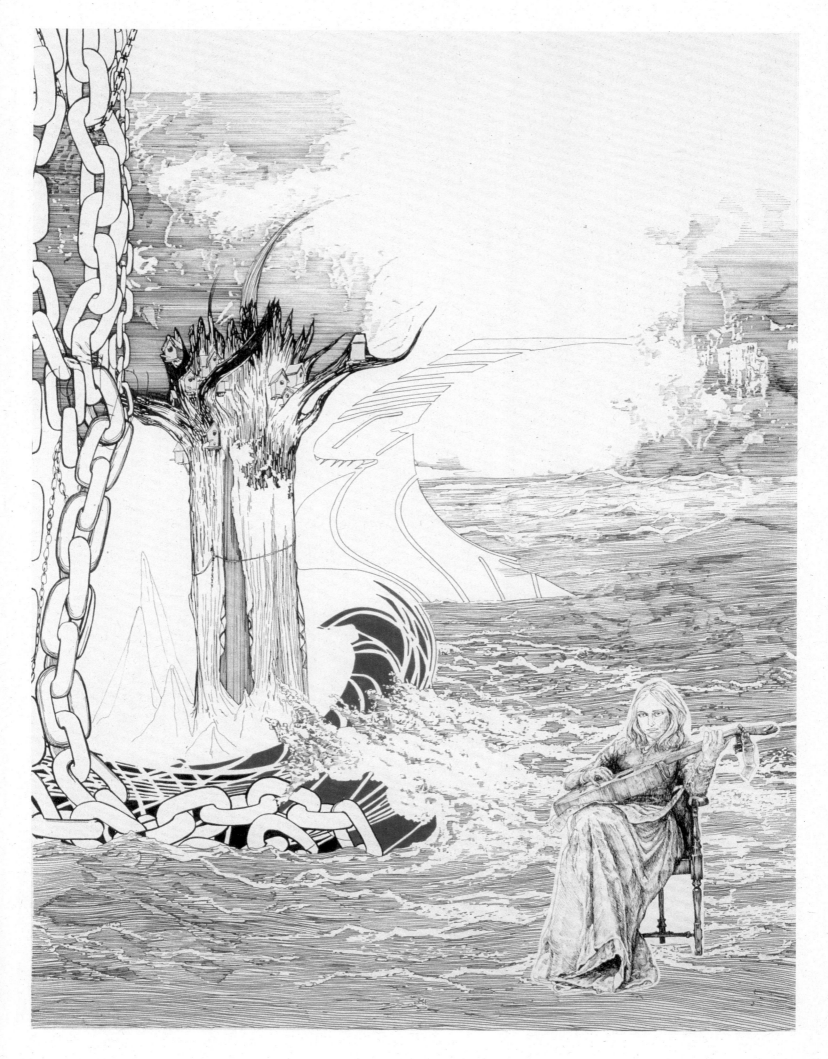

FLOW AND ARREST OF THOUGHTS, 2001 | ABOVE

KILLOFFER

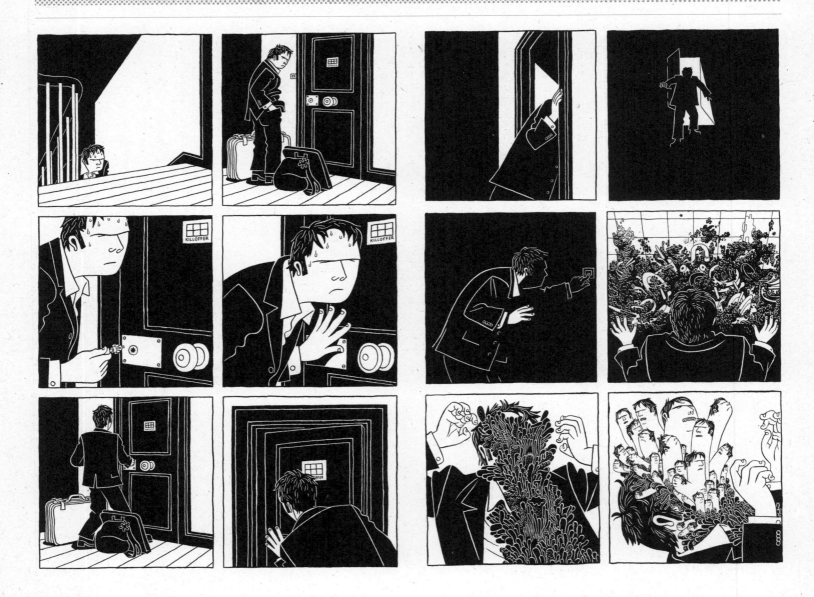

Born in 1966 in Lorraine, France, Killoffer studied at Bibliothéque l'École des Arts Appliqués Duperré in Paris. In 1990 he co-founded L'Association, a group determined to publish more 'irregular' comics in opposition to the mainstream Bande Dessinée. Later he also co-founded the OuBaPo (Ouvroir de la Bande Dessinée Potentielle), an avant-garde collective who experiment with the possibilities of comics in the face of various challenges and constraints.

In SIX HUNDRED AND SEVENTY-SIX APPARITIONS OF KILLOFFER, 2005, autobiography is taken to another level – as is the idea of travel writing. The comic chronicles his journey from Paris to Montreal and back again as he is besieged by clones of himself. In part inspired by M. C. Escher, his very sophisticated graphic style dispenses with grids and panels and allows the protagonist – in this case himself – to tell the story by spilling drawings across the page. The dirty dishes festering in his kitchen sink launch an evening of abject debauchery that includes fights and an attempted rape, and eventually leads to a pile of dead bodies. Killoffer perpetrates all of this activity with multiple versions of himself, as many as 676 times. The result is epic. Killoffer's unique approach offers us another way to read sequential narrative, taking the current vogue for comic book autobiography to a self-obsessed, self-destructive extreme.

Sherman Sam

ABOVE & OPPOSITE | SIX HUNDRED AND SEVENTY-SIX APPARITIONS OF KILLOFFER, 2002

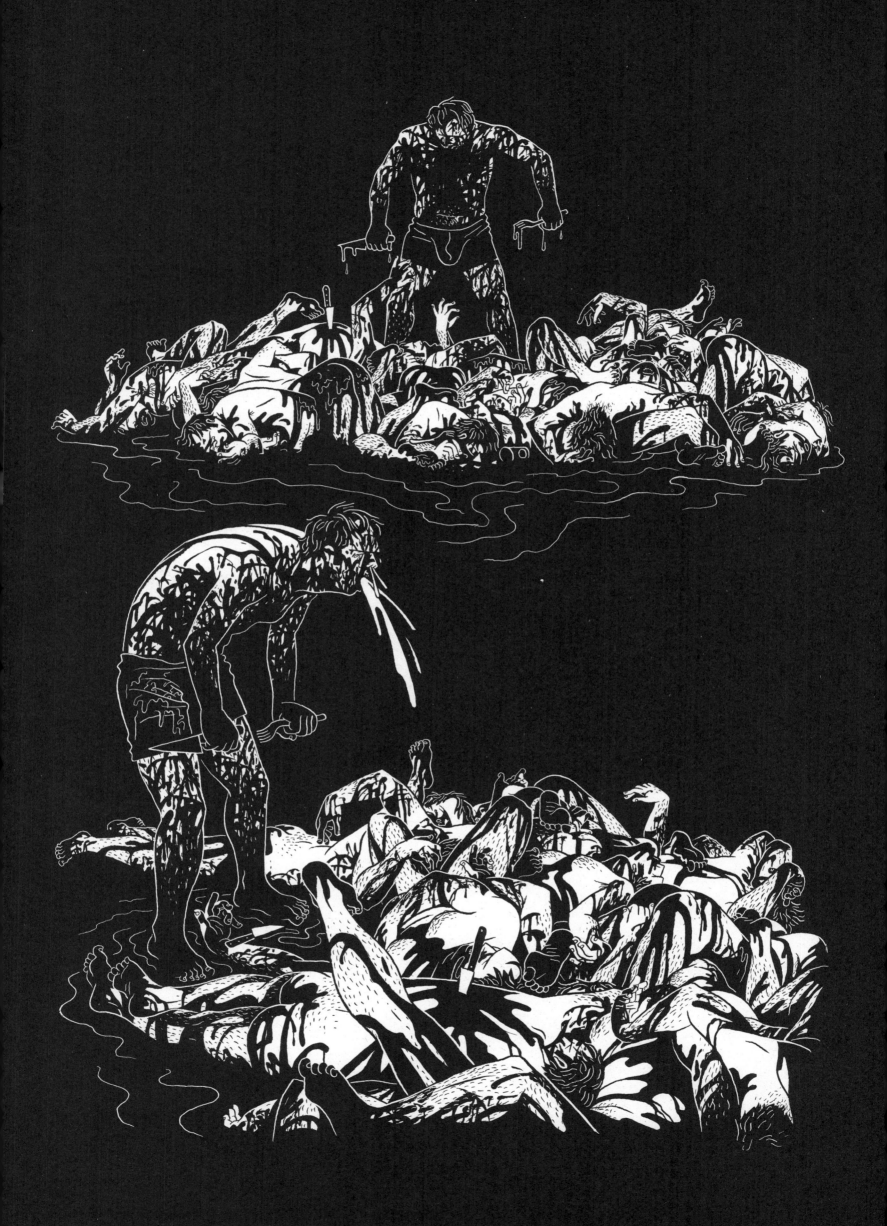

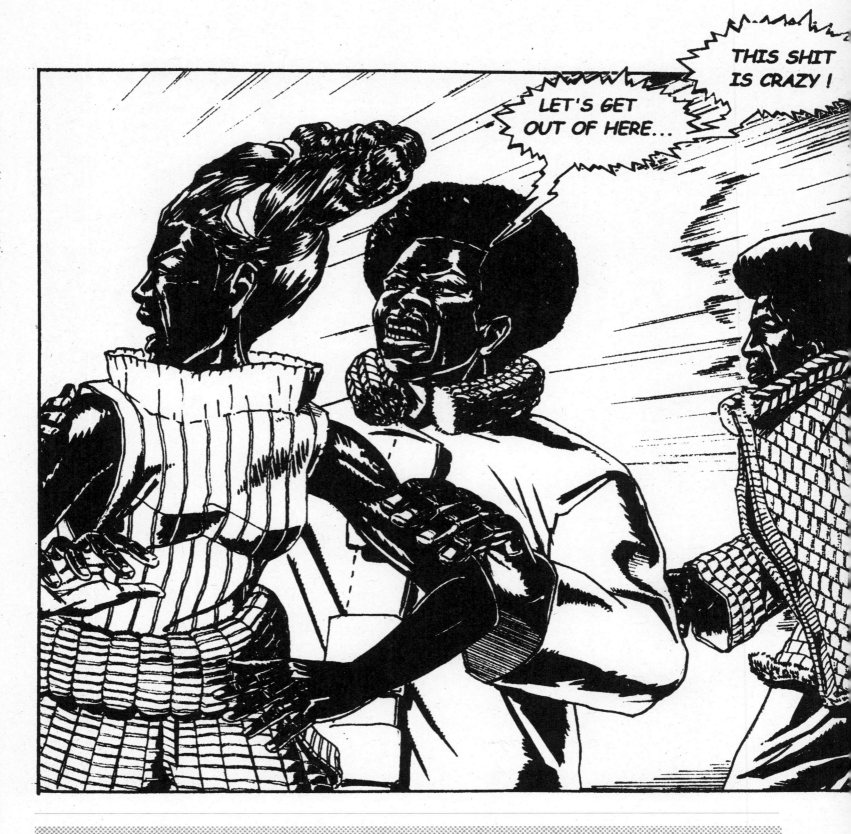

KERRY JAMES MARSHALL

Born in 1955 in Birmingham, Alabama, Kerry James Marshall grew up in Los Angeles, where he studied at the Otis Art Institute. Since 1993 he has been a professor at the School of Art and Design and the University of Illinois, Chicago.

The subject matter of his paintings, installations and public projects addresses social and cultural issues that shape the lives of African Americans, and is rooted in his childhood experiences during the period of the Civil

Rights and Black Power movements: 'You can't grow up in South Central [Los Angeles] near the Black Panthers headquarters, and not feel like you've got some kind of social responsibility,' he says. 'That determined a lot of where my work was going to go.'

RYTHM MASTR is a comic strip featuring a cast of African American superheroes who battle against the evil forces of cybertechnology. Kerry James Marshall explains that he created RYTHM MASTR partly because while

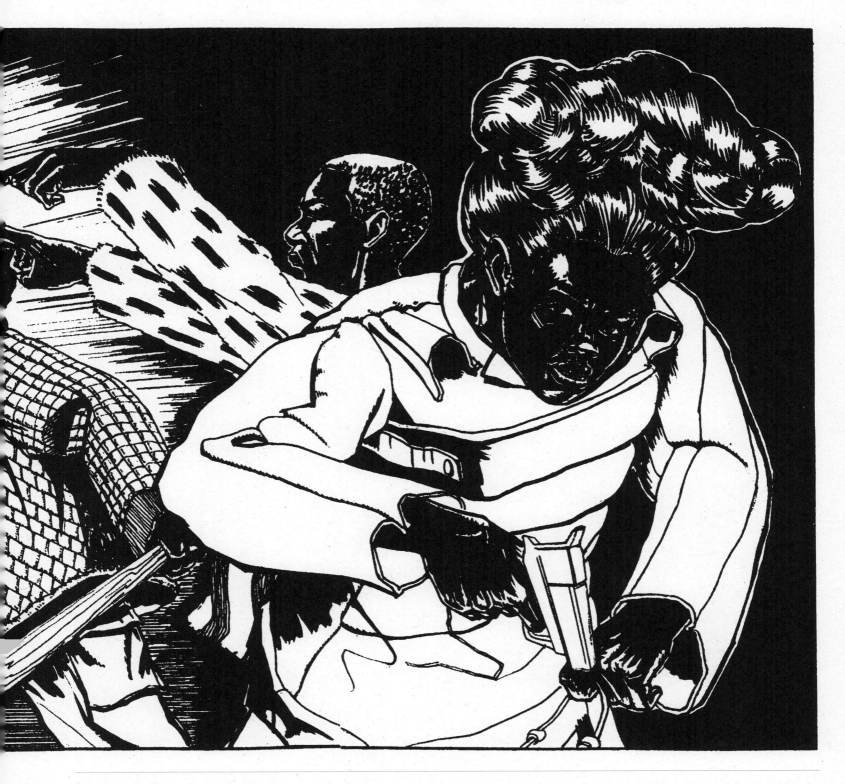

'black kids are interested in comics and super heroes just like everybody else' there were very few super heroes who were black. 'When I was growing up, reading Marvel comics,' he recalls, 'THE X-MEN, THE FANTASTIC FOUR, THE AVENGERS, THOR, THE MIGHTY HULK, SPIDERMAN – all of those characters were amazing characters to me. But there weren't any black characters in the pantheon of super heroes until the Black Panther entered the scene in FANTASTIC FOUR, issue 52 in 1965.'

Marshall's own super heroes derive from West African deities: 'There's a pantheon of gods in the Yoruba tradition that is known as the seven African powers, and those African powers are represented in African sculpture symbolically. When we go to the museum to see African art, those symbolic representations of the heroes seem pretty inert. We talk about them as statues that are from cultural practices that are either dead or obsolete.' In RYTHM MASTR, a very specific group of African sculptures is transformed into super powers in order to preserve and transmit aspects of traditional African culture into the twenty-first century and beyond. Kerry James Marshall says, 'I'm trying to find a way to make our knowledge of African history, our

knowledge of mythology, and our love of fantasy and super heroes and things like that all come together in a vital and exciting way by connecting it to a story that is meaningful, historically and culturally, and that says something about the way in which we can carry these traditions into the future so that they don't have to dissipate and die.'

Helen Luckett

Panel from RYTHM MASTR, 2006 | ABOVE

we are driven by th

CHAD McCAIL

Chad McCail was born in 1961 in Manchester and grew up in Edinburgh. Having first read English at the University of Kent, he later graduated in Fine Art from Goldsmiths College, London. His work explores the links between sexual repression, violence and totalitarian obedience. Accompanied by slogan-like captions, his brightly coloured paintings and digital works are reminiscent of educational graphics but also draw on visual sources as various as Egyptian hieroglyphs and vintage science fiction. Besides creating storyboards, free-standing panels and billboards he has published a graphic novel, ACTIVE GENITAL, 2002, and an online sim-society game based on his drawings, SPRING_ALPHA, has been devised by Simon Yuill.

McCail's narratives of power, desire and innocence present an anarchic nowhere land, portrayed in a style familiar from old-fashioned school

desire for pleasure

books, in which idealistic communities battle against the grim realities of contemporary life. His aim, he explains, is to explore 'the possibility of inspiring people by suggesting that a harmonious world can be created by a struggle for a sharing of responsibilities and the development of the senses of stewardship, courage, imagination and love.' LIFE IS DRIVEN BY THE DESIRE FOR PLEASURE, an on-going project begun in 2000, carries this mission further: 'I'm presenting two fictional worlds – one, where people have a harmonious and dynamic understanding of their desires and another where the desire is inhibited and bound up with violence in the interests of a wealthy elite.' The work illustrated here concerns sex education. As with all his works, the message is conveyed not so much by the strident, propagandising caption as by the small, all-important detail. And, in this work, the cheerful, aphoristic slogan is essentially a lie.

McCail's key influences include the Austrian psychiatrist and psychoanalyst Wilhelm Reich, a pioneer promoter of healthy adolescent sexuality and an exponent of the social and political effects of sexual repression; A. S. Neill, the creator of the original alternative 'free' school and advocate of progressive, democratic education; and the social psychologist Stanley Milgram, who studied the willingness of people to obey a person in authority in spite of their own personal consciences.

Chad McCail has created two new works especially for this exhibition.

Helen Luckett

WE ARE DRIVEN BY THE DESIRE FOR PLEASURE, 2006 | ABOVE

PAUL McDEVITT

Born in Troon, Scotland in 1972, Paul McDevitt attests to a youth spent reading comics and painting 'Dungeons and Dragons' figures – a legacy perceptible in the obsessively detailed quality of his drawings. He studied at Lancaster University and Chelsea College of Art and Design where, after graduating, he became Saatchi Fellow in Residence. It was during this period that he produced 22,000 YEARS IN 260,100 SECONDS, a biro drawing depicting an

invented cosmic constellation whose title is descriptive of both the time it takes light to travel to Earth from the furthest reaches of the galaxy, and a precise calculation of how long it took McDevitt to complete the drawing (72 hours, 25 minutes). He currently lives and works in Berlin where he continues to produce incredibly intricate and labour-intensive drawings, but has since exchanged his Bic biros for coloured pencils.

ABOVE | FIRST DATE, 2005

ARTIST, Paul McDevitt

McDevitt's drawings interweave disparate elements from natural and cultural histories. Authoritarian modernist buildings, avant-garde design motifs, constructivist artworks, science fiction and cartoon characters are depicted in fantastic landscapes under spectacular skies. The drawings and woodcuts of the nineteenth-century Japanese artist Katsushika Hokusai provided the starting point for THE GHOST OF DECLAN CLARKE (AFTER HOKUSAI). McDevitt transposes his representation of the GHOST OF O-IWA, depicted by Hokusai in a Buddhist lantern, onto a hammock strung between two trees in a lush tropical rain forest. In the foreground graphic motifs, reminiscent of coral or possibly foaming surf, creep into the picture plane like traces of ghostly ectoplasm. The artist began introducing images of ghosts into his drawings following the death of a close friend, and in this image the spectral disembodied head of Japanese folklore also serves as a caricature of the artist's (living) friend and collaborator Declan Clarke, whom he condemns to haunt this idyllic setting.

A contemporary Japanese cultural phenomenon – KAWAII (the culture of cute) – sets the tone for FIRST DATE. The stylised form of the two cartoon kittens, depicted floating in an infinite black cosmos, is inspired by Manga and Anime (Japanese comics and animation). Cosmic skyscapes frequently recur in McDevitt's drawings as backdrops to a disparate collection of outmoded cultural references, which he skilfully cuts and pastes into harmonious compositions that summon revisionist overviews of our past.

Emma Mahony

GHOST OF DECLAN CLARKE (AFTER HOKUSAI), 2005 | ABOVE

TRAVIS MILLARD

The proprietor of The Fudge Factory (est. 1997), Travis Millard, was born in St. Joseph, Missouri in 1975. He moved to Kansas to study illustration and printmaking at Kansas University. In 2000 Millard relocated to Brooklyn, but by 2003 he moved westward in search of sunny skies and cheap rent, landing in LA where he currently lives. The Fudge Factory is a retail umbrella Millard set up to distribute his artist's books, prints and mechandise.

Travis Millard's practice is rooted in drawing; working primarily in black ink with occasional splashes of colour, Millard embraces a nostalgically adolescent, street art aesthetic. In the artist's own words, Fudge products are 'a chilling reflection of today's disaffected individual caught by the banal deceptions of the daily barrage of our rabid consumer driven society.' There is a light-hearted, comedic touch to Millard's work, the subject matter of which ranges from the minutiae of everyday detritus found in a magnified cross section of the artist's moustache (which include donut dust, photocopier toner and model airplane glue) to variations on classic one-liner gags – as in the multi-lingual tales of THE DUDE WITH NO PANTS ON. Critiques of consumer culture and caricatures of right-wing politicians and outmoded pop stars make up the more biting content of recent hand-stapled, limited edition comics. The unfortunate pupils of a school for hirsute children are immortalised in his mini-zine CLASS PICTURE DAY AT THE SCHOOL FOR HAIRY FACED CHILDREN. The book is composed of a series of photocopies of large-scale ink drawings from which the character of SALLY, with her full-toothed smile and shiny hair clips, is taken.

Oriana Fox / Emma Mahony

ABOVE | BRAYED HOME, 2006
OPPOSITE | SALLY, 2004

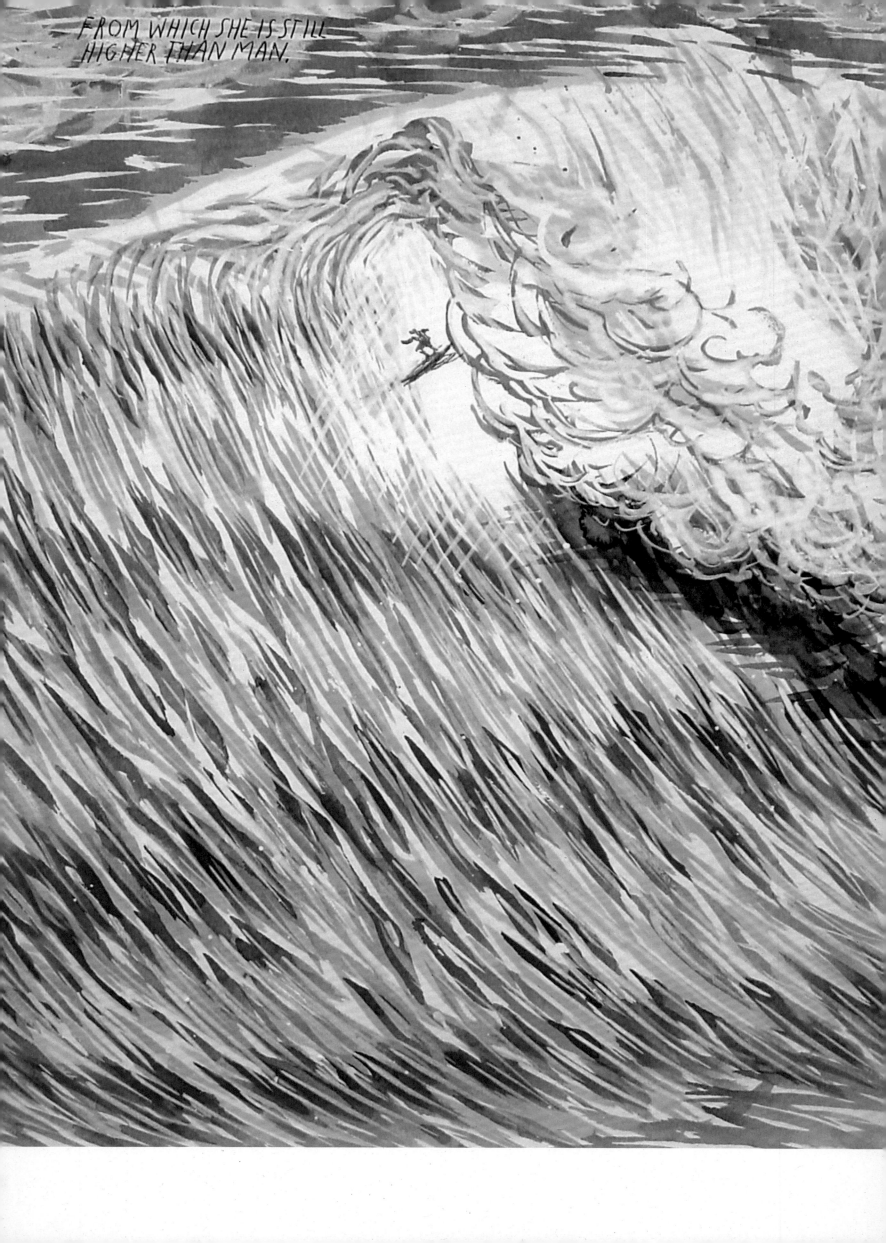

RAYMOND PETTIBON

Raymond Pettibon was born in 1957 in Tucson, Arizona, and raised in Hermosa Beach, considered to be the birthplace of Californian surfing. He studied Economics at UCLA and taught high-school maths for a brief period, before becoming an artist. In the late 1970s and early 80s, his drawings for album covers, Xeroxed flyers and pamphlets for Punk bands like Black Flag, Minutemen and Sonic Youth had already brought him cult status before he began exhibiting his work in galleries. Drawn into the Punk scene by his brother Greg Ginn, a founding member of Black Flag, he became the unofficial artist for their label, SST Records. In 2002 Pettibon gained more widespread popular exposure when commissioned to design the artwork for the Foo Fighters' ONE BY ONE album.

Pettibon is renowned for his rough and agitated black-ink drawings that combine imagery with text, and explore issues as diverse as politics, pop culture, baseball and surfing, augmented with quotations from literary sources like Henry James, William Blake, Mickey Spillane, Samuel Beckett and the Bible. Speaking about the genesis of his work he has said: 'I wanted to retain the writing and representation, the figurative imagery, the people

and places from that time, and to do that within my own means and talents and capabilities. That lead me into an illustrative-comic style, which I think is useful for what I do. And I retain that to this day. But my drawing also came out of editorial-style cartoons I was doing at the time'.

The popular and cult imagery – references to Charles Manson, Superman and Elvis Presley – that pervade Pettibon's landscape, lends it a filmic and pulp fiction quality. Pettibon describes Gumby (a popular claymation figure from the 1950s) and Vavoom (a character with a loud voice from the FELIX THE CAT cartoons) as representing alter egos for his work as an artist.

Sherman Sam

OLIVIA PLENDER

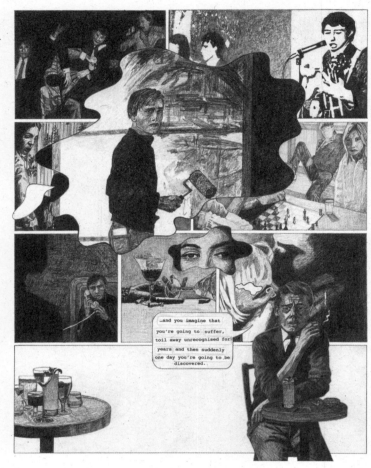

Olivia Plender was born in London in 1977 and studied at Central St. Martins College of Art and Design. Prompted by an interest in parapsychology, spiritualism, romanticism and magic, Plender makes art which dips in and out of bohemian and alternative cultures, and manifests itself as drawings, comic books, magic shows, performances, lectures and film.

THE MASTERPIECE, started in 2001 and now in its fifth and final episode, uses the format of the comic strip to explore the mythology or cliché of the 'artistic genius'. Borrowing its title from Émile Zola's 1886 novel, THE MASTERPIECE follows the exploits of 'Nick', a relatively unknown painter, through the London art scene in the 1960s as he pursues his ultimate goal: to produce a masterpiece. The comic itself – although meticulously hand drawn in pencil – is a cleverly collated web of cultural references, borrowed images and appropriated storylines. Characters, images and narratives are cut and pasted from sources as diverse as 1950s pulp novellas, literary quotations, nineteenth-century technical manuals, fictional mythologies, film stills, screenplay dialogue and comic books compiled into a highly dramatic tale. The result is arguably an original work of illustrated post-modern fiction.

Not a childhood fan of comics, Plender's fascination for the medium has developed more recently. Its appeal for her lies in its accessible format, the equal importance it places on word and image and its potential for wider distribution. Central to this work is a cleverly and deliberately constructed paradox in which the concept of the masterpiece – a unique work of genius, impossible to replicate – is pursued in a medium chosen for its affordable and throw-away nature. In the artist's words: '…the form the work takes of a mass-produced comic is in deliberate contrast to the unique one-off masterpiece that the central character is obsessed with making.'

The comic book format is one of several media – which also include film and performance – through which Plender expresses her interest in how values and ideals from the past retain a cultural relevance in the present.

Emma Mahony

ABOVE & OPPOSITE | 'Evil Genius', THE MASTERPIECE, Issue 3, 2004

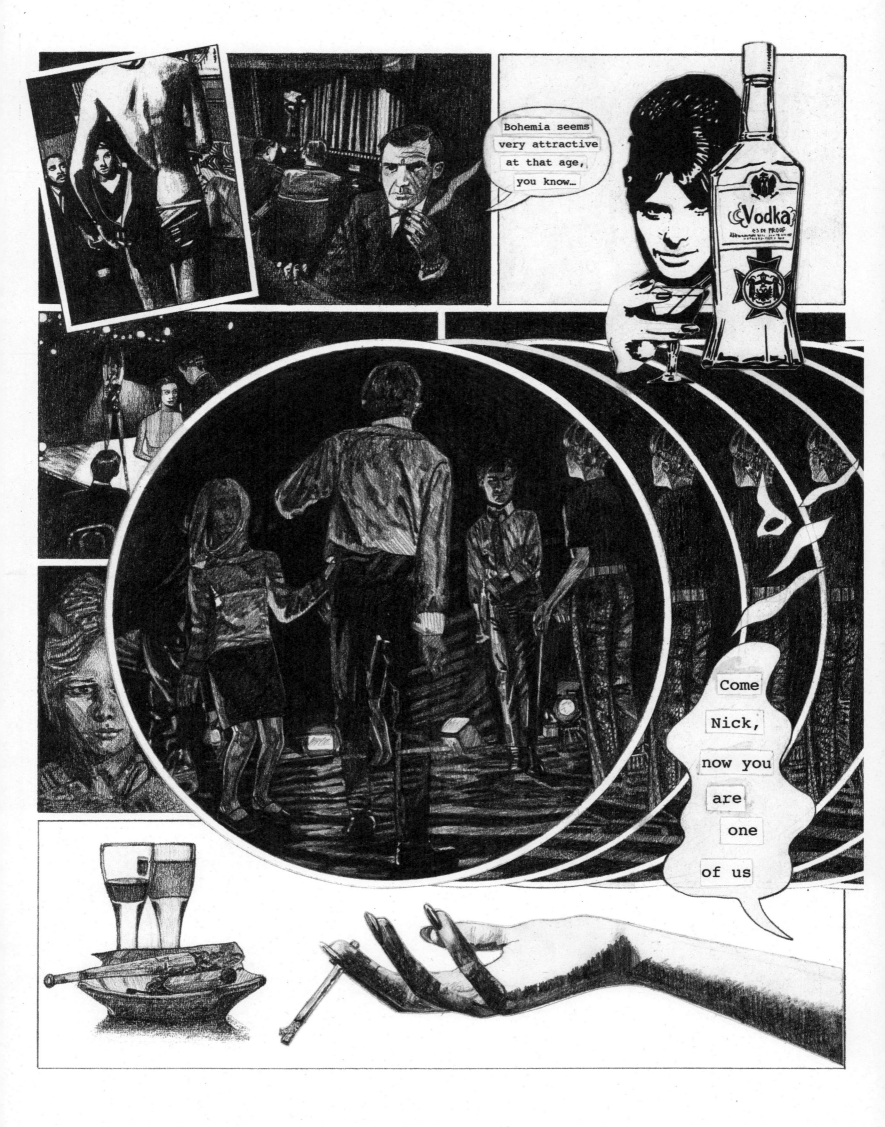

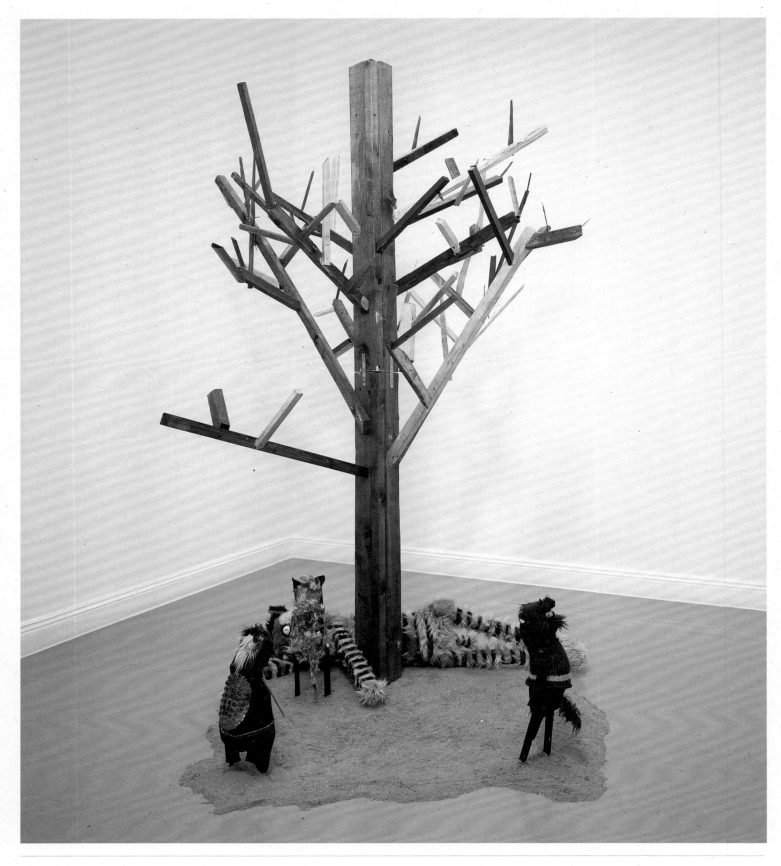

Jon Pylypchuk was born in Winnipeg in 1972 and studied at the University of Manitoba. He is a former member of The Royal Art Lodge, which he co-founded with Marcel Dzama and other similarly minded, socially dysfunctional and geographically isolated young locals who had a lot of time on their hands and liked to draw. In 2000, Pylypchuk quit the 'Lodge' and the snow drifts of Winnipeg for the sand dunes of California where he attended the University of California. He currently lives and works in New York.

A dubious cast of characters congregate in Pylypchuk's sculptural tableaux. Mangy flea-bitten animals that look as though they have been dragged along a dirt track interact in his melodramatic scenes. Each furry reject has been haphazardly fashioned from scruffy bits of fake fur, rags and scraps of wood, held together with glue and lovingly brought to life with socks, neck ties, shirt cuffs and collars. Thrashed, dejected and damaged — both physically and psychologically — the malevolent creatures subject each other to acts of

indignity, crying, vomiting and pissing on each other and engaging in acts of sexual deviance in a cycle of violence, abuse and counter abuse.

The acute emotional states his characters display — loneliness, guilt, shame, pain and sexual desire — are indicative of the universal needs of humans; the fear of rejection and a need to be loved. Pylypchuk has said that the impetus for his work is to make art that deals with 'the most tragic aspects of my life' (a reference to the loss of family members). Despite their suffering and the frequent absurdity of their situations, his characters display a determination to make the most of their sorry lot. Pylypchuk's characters might be in the gutter but they are looking (quite literally in some works) up at the stars and the angels. The wry humour is life-affirming.

Emma Mahony

JON PYLYPCHUK

I MISS YOU, DANGER, AND ALL ITS ELEMENTS, 2006 | ABOVE

ABOVE WILF – A LIFE IN PICTURES, 2004
BELOW CAPTURE HILL '78, 1999

JAMES PYMAN

Born in Eastbourne in 1962, James Pyman attended Sheffield City Polytechnic and currently lives in London. He began by writing and drawing short comic book stories for various magazines and in 1994 he self-published NINE PANEL GRID, a collection of semi-autobiographical stories designed in a '3x3 frame' page format. His children's comic book, THE ADVENTURES OF LIONEL: THROUGH THE MOON, was first published in 1997.

In James Pyman's large-scale pencil drawings and ink cartoons, historical events, everyday occurrences and familiar cultural ephemera come together to create politicised and nostalgic storylines. WILF – A LIFE IN PICTURES purports to be the life's work of a fictitious editorial cartoonist who commented on real world events in an imaginary newspaper from the 1960s to the 1990s. A series of black and white drawings accompanied by one-line captions, the work represents 30 years of social commentary, in fact produced by Pyman

over the course of a single year. Described by the artist as 'a biography from a parallel universe where history is informed by the present,' popular music bands and wigged judges of the 1960s, TV characters imported from America in the 1970s and spotty, jeans-clad students of the 1980s star in single framed illustrations of a stereotypical Britain.

The young boys depicted in CAPTURE HILL '78 appear to be poised in anticipation of an imagined enemy. The source for Pyman's drawing is an advertisement for GI Joe toys, which he meticulously translates in pencil on a scale that is almost life-size. Like the comic book heroes they imitate, their battles are inspired by real life events.

Alice Lobb

WILF – A LIFE IN PICTURES, 2004 | ABOVE

JOE SACCO

A Maltese citizen currently based in Portland, Oregon, Joe Sacco was born in 1960 and studied journalism at the University of Oregon. In the early 1980s he published his first comics in his native Malta – a romance series, IMHABBA VERA (TRUE LOVE). As his comic books document, Sacco travels widely. In addition to his time in Portland, where he co-published the PORTLAND PERMANENT PRESS, Sacco has also lived in Los Angeles, where he worked for Fantagraphics editing THE COMICS JOURNAL, and Berlin, New York and Berne, producing various comics and 'reporting' on rock bands. He received the American Book Award for PALESTINE in 1996.

In his graphic novels, PALESTINE and SAFE AREA GORAZDE: THE WAR IN EASTERN BOSNIA 1992–95, Sacco employs eyewitness reportage to tell stories that have been systematically excluded from mainstream news coverage. PALESTINE grew out of the time he spent travelling in Israel and the Occupied Territories, an area he was impelled to visit, feeling that 'American coverage of the Middle East [was] very shallow'. PALESTINE is a unique form of social commentary describing ordinary people on both sides of the conflict. Naughty kids, hawkish shopkeepers, peaceful demonstrators, flirtatious

soldiers and tortured prisoners are given equal treatment, drawn in Sacco's usual big-toothed, large-lipped style. He states: 'a journalist always connects better with the people around her or him than with a general or a politician. Those people are built to spin – that's what they do. I will interview bigwigs if I get the chance, but you are seldom surprised by people in power – you've got to get awfully damn close to get anything new. I'd much rather hang out in a café. That's where things are really happening.'

His frontline journalistic approach, coupled with his caricaturist-cartoon style, enables him to speak about difficult and politically charged truths in an engaging and accessible medium. Citing Hunter S. Thompson, Michael Herr and George Orwell as influences, he says that history 'can make you realise that the present is just one layer of a story. What seems to be the immediate and vital story now will one day be another layer in this geology of bummers.'

Sherman Sam

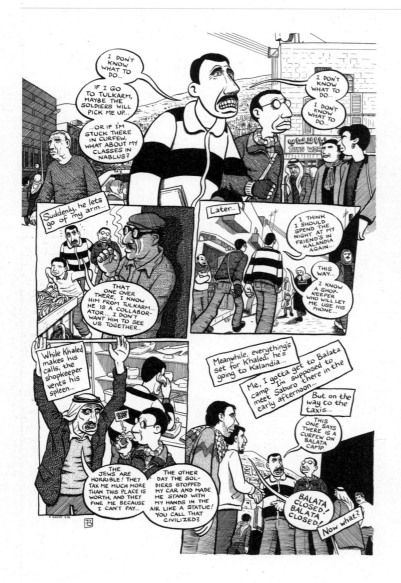

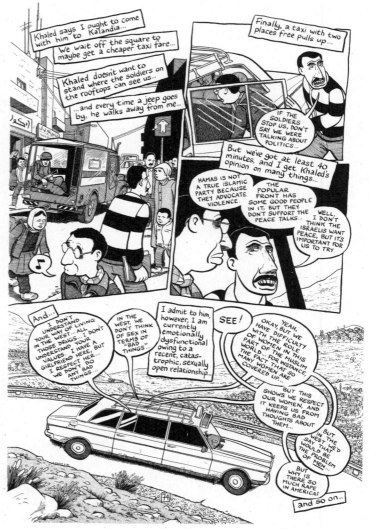

ABOVE & OPPOSITE PALESTINE, 1994

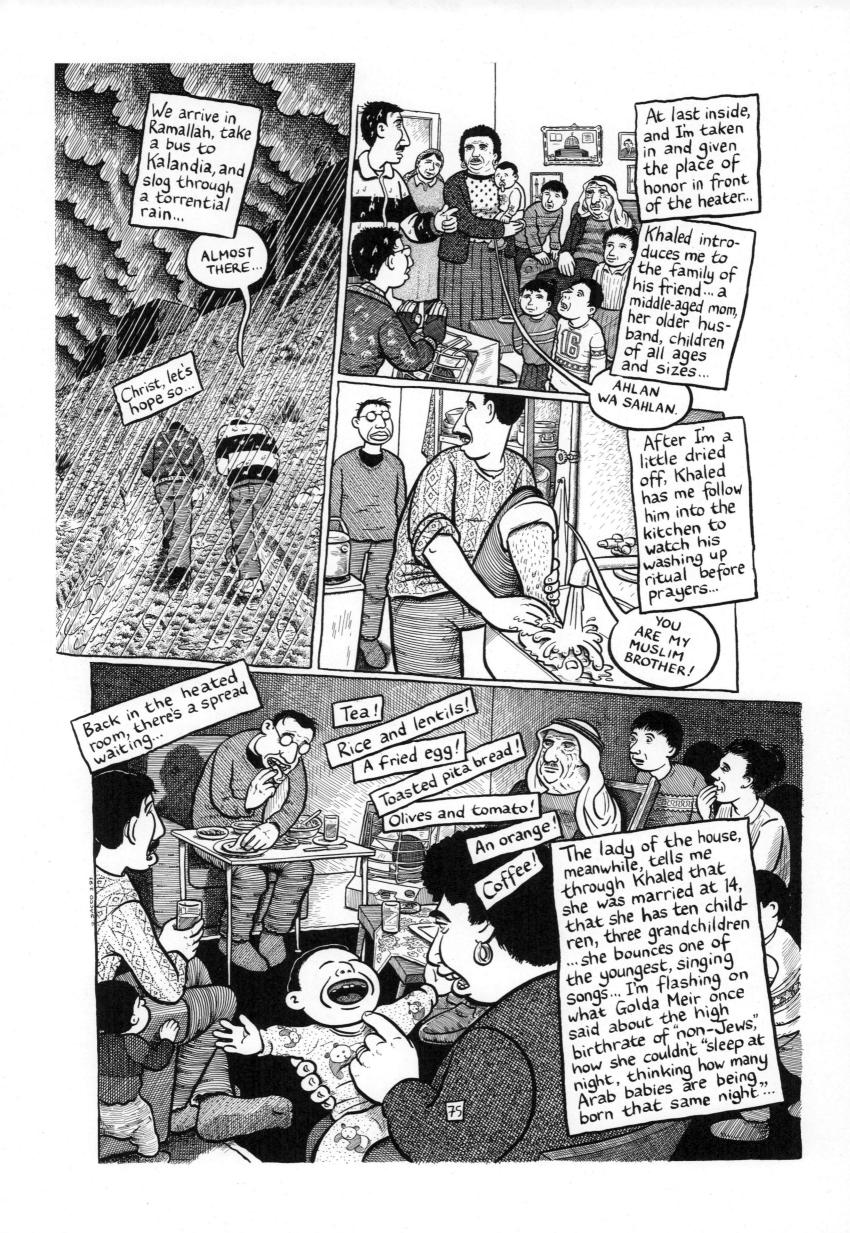

DAVID SHRIGLEY

IN COLLABORATION WITH
YOSHITOMA NARA AND CHRIS SHEPHERD

Who is David Shrigley and what does he want? England's best-known doodler was born in Macclesfield, Cheshire, in 1968. He studied Environmental Art at Glasgow School of Art and he still lives in Glasgow. After several failed attempts to be published as a cartoonist in the style of Gary Larson, Shrigley set about self-publishing books of his drawings and has to date produced over 20 titles through his own imprint, Armpit Press, and other publishers.

As to what Shrigley wants, his animated film suggests that he might be a sadistic psychopath who wants to live alone in the woods. But WHO I AM AND WHAT I WANT is simply one of the manifestations of a delightfully twisted imagination, which also expresses itself in drawings, books and sculptures. Based on Shrigley's book of the same name, the animation grew out of a collaboration with Chris Shepherd, who wrote and co-directed this darkly humorous exploration of the human condition.

Shrigley has a unique worldview – a slightly autistic, perverse and unfiltered understanding of humanity and its sometimes painful struggle with existence. His spidery meanderings in pen and ink present us with surreal sce-narios that mirror our subconscious desires and fears. A community of misfits, beasts and tortured animals explore moral themes such as good, evil, love, hate, life and death in scenarios which are as comic as they are tragic.

His drawings are frequently annotated with scribbled fragments of subconscious thought. A drawing of a caged beast produced in collaboration with the Japanese artist Yoshitomo Nara bears the title IF YOUR SOUL IS NOT A LUCKY ONE IT WILL FALL INTO THE HANDS OF ZOO, leaving the reader to arrive at their own meaning. Caged creatures continue to preoccupy Shrigley in his sculptures PET CARRIER NO.2 and CAT BASKET NO.2. In both works we are presented with a frozen narrative, a moment after the fact. Yellow slime oozes out of the enclosures, provoking our curiosity as to the fate of the former occupants. Whether they were liquidised with a laser gun, or were the hapless casualties of a scientific experiment gone horribly wrong, is left for the viewer to decide.

Emma Mahony

ABOVE | David Shrigley and Chris Shepherd, WHO I AM AND WHAT I WANT, 2005

CAT BASKET NO.2, 2003 | ABOVE
PET CARRIER NO.2, 2002 | BELOW

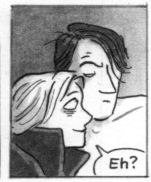
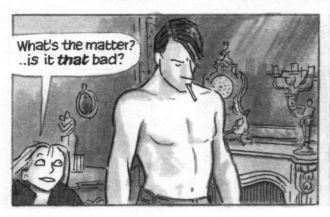
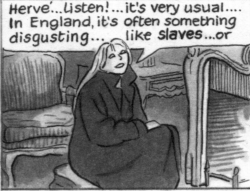
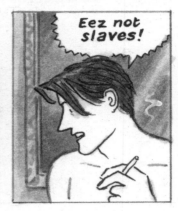
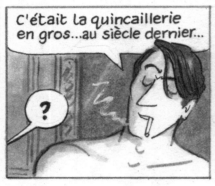

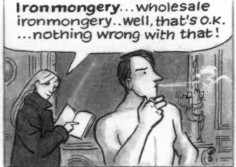
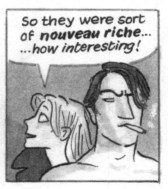

POSY SIMMONDS

Posy Simmonds was born in 1945 and grew up in Berkshire. She studied graphic design at the Central School of Art in London. Since 1973 she has drawn for the GUARDIAN as well as writing and illustrating numerous children's books. Her first strip recounted the lives and preoccupations of middle class leftish academics in the 1970s and 80s, and became a cult favourite among the class it satirised. In the late 1990s, her graphic novel, GEMMA BOVERY, also first serialised in the GUARDIAN, adapted Gustave Flaubert's novel MADAME BOVARY to tell a story of adultery in a community of English ex-pats in rural Normandy. This was followed by LITERARY LIFE, a miscellaneous series of parodistic strips and jokes mocking the predicaments, frustrations and pretensions of contemporary writers and literary types in London and the countryside. Her most recent serial, TAMARA DREWE, concluded in December 2006.

Posy Simmonds is one of the most original and sophisticated exponents of the modern graphic novel. Equally accomplished as a draughtsman and as a writer and storyteller, she is a truly literary artist; both drawing and dialogue are finely tuned, combining social observation with delicate irony.

She has an acute eye for relationships – between the sexes, generations, town and country, the French and the English – and the ability to create consistently believable personalities. Each character is defined by distinctive mannerisms, gestures and telling details: the cut of a jacket, a balding pate, a comfortable paunch, hunched shoulders, a conceited air, perky or sagging breasts, an unfashionable cardigan, stylish shoes. The balance between image and text varies according to the pace of the story, sometimes one overwhelming the other, and the combination of hand-written dialogue and printed commentary allows the narrative to lead with authority and set the pace. Her drawing style is reminiscent of Rowlandson's in its fluency and humour, spiced with eroticism.

Roger Malbert

ABOVE GEMMA BOVERY, Episode 63 (Detail), 1999

OPPOSITE GEMMA BOVERY, Episode 47, 1999

A note on Gemma's food:
It's prejudice, but one doesn't expect great things dining *chez les anglais* – I'd resigned my guts to some peasant mess to match the decor.
In fact Gemma had been quite extravagant. (Was I the only one to find it a little distasteful to sit in this pastiche of rural poverty eating *filet de boeuf* at 165 francs the kilo?) The wine (St Nicholas de Bourgeuil 1976) was excellent and the dinner was bizarre rather than bad. For example, why serve expensive fish <u>raw</u>? Why turn it into a plate of Lego?

If Gemma *had* committed adultery, she gave nothing away at dinner. There were none of the usual signs – no guilty over-attentiveness to her spouse; none of those smiles and blushes that arrive unbidden with some steamy recollection. No, Gemma wore her usual cool expression. (Fishes look at you with more animation.) I began to think I was wrong. Nothing had happened. She was probably a prude and, in any case, she didn't look the part of an adulteress – or certainly not the literary one I had in mind. (Exquisite, dark, refined, yet possessed of a fulminant sexuality.)

This British Madame Bovery looked like some kitchen skivvy, with her greasy apron, the soles of her feet rather black, her face a little pink from the oven and the sweat glistening between her shoulder blades. (Actually, I like the shine of a woman's hot skin.)

On her arm I noticed two weeping insect bites . . . and on her neck . . .

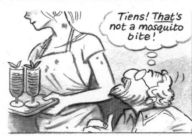

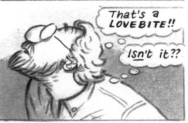

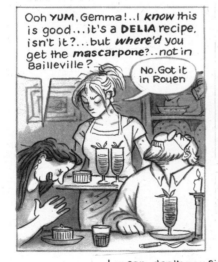

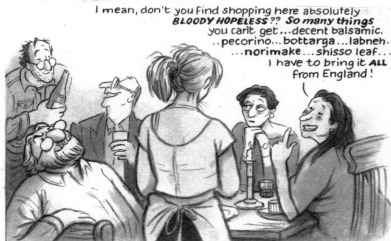

It was a lovebite! I was sure of it. Passion's Postmark. Passion with Hervé de Bressigny.

RICHARD SLEE

Richard Slee was born in 1946 in Carlisle. He studied in London at the Central School of Art and Design and the Royal College of Art. He currently lives and works in London and Brighton.

Richard Slee's ceramic works subvert our understanding of familiar objects. Taking a range of innocuous domestic items as his starting point, he recreates them in Technicolor and on a scale that is slightly larger than the original. The resulting sculptures are surreal interpretations of the functional objects they mimic.

Inspired by the KRAZY KAT comic strips of George Herriman and Disney animation, his work is both comic and ironic in tone. In a recent body of work, objects typically found in hardware stores, such as brooms, hooks and trowels, are recreated in ceramic and mixed media. A hefty metal meat hook is the inspiration for its ceramic facsimile, S, which is fired in a convincingly realistic metallic glaze. Stripped of its functionality, its comic potential takes centre stage. Not unlike the props produced by the fictional ACME Corporation for the Looney Tunes cartoons, Slee's sculpture isn't really up to the job of the S-hook it apes. Put to the test it's likely to backfire ridiculously. Similarly, the practicality of his rainbow-coloured BROOMS is seriously impeded by the clear plastic tripod legs on which they balance. Acting as ironic imitations of the bristles of a brush head, they render the objects completely unsuitable for the task of sweeping a floor.

Like the brooms that he displays casually propped in the corner of the gallery as though forgotten by the cleaners, the nature of much of Slee's recent work calls for it to be leant or hung, resisting the traditional conventions associated with the display of craft objects. Instead it acts as sculptural interventions serving to disrupt the gallery space in a comedic fashion.

Emma Mahony

| ABOVE | PISTOL, 2007 |
| BELOW | NECKLACE (FOR BUNNY), 2006 |

s, 2005 | ABOVE

CAROL SWAIN

Carol Swain was born in London in 1962 and raised in Wales. She describes growing up in a beautiful but inhospitable landscape, populated by 'an odd mix of outsiders, hippie folk, and local farmers, plus a few "mean Baptist hysterics", to quote Hunter S. Thompson'. After studying painting at Stoke-on-Trent, she returned to London in 1987, where her self-published comic WAY OUT STRIPS brought her to the attention of a wider audience. Her memories of Wales have inspired some of Swain's most poignant stories, including FOODBOY. She is currently collaborating on a graphic novel with her partner Bruce Paley entitled TALES FROM A ROCK'N'ROLL LIFE, and she is planning a third graphic novel, also set in Wales.

Rural mid-Wales is the setting for FOODBOY, the tale of a strange relationship between a feral outsider, Ross, and Gary 'the foodboy', who befriends him. The title 'FOODBOY' is derived from Serbian, meaning 'grunt' and is described by Swain as: 'the young men that do the fighting, the dirty work. Whilst the warlords get rich safely away from the action.'

Swain's rough angular charcoal drawings and sparse dialogues reinforce the story's desolate atmosphere, keeping the reader at a distance from the increasingly alienated protagonists. We are left to follow Gary as he trails across the bleak landscape in search of his friend. Describing the relations in FOODBOY Alan Moore remarks: 'the emotions and loyalties here could be Palaeolithic, as old as the weather-chewed landscape itself.'

Sherman Sam

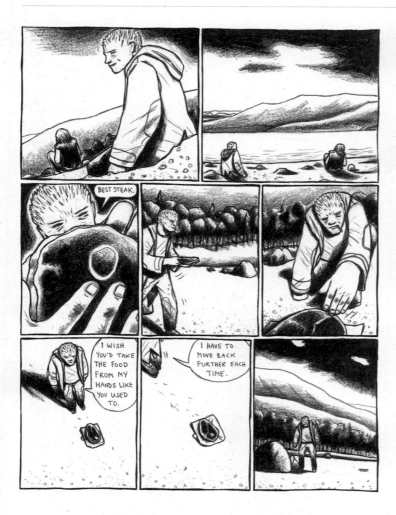

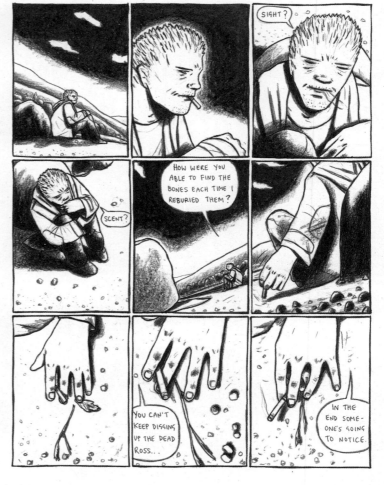

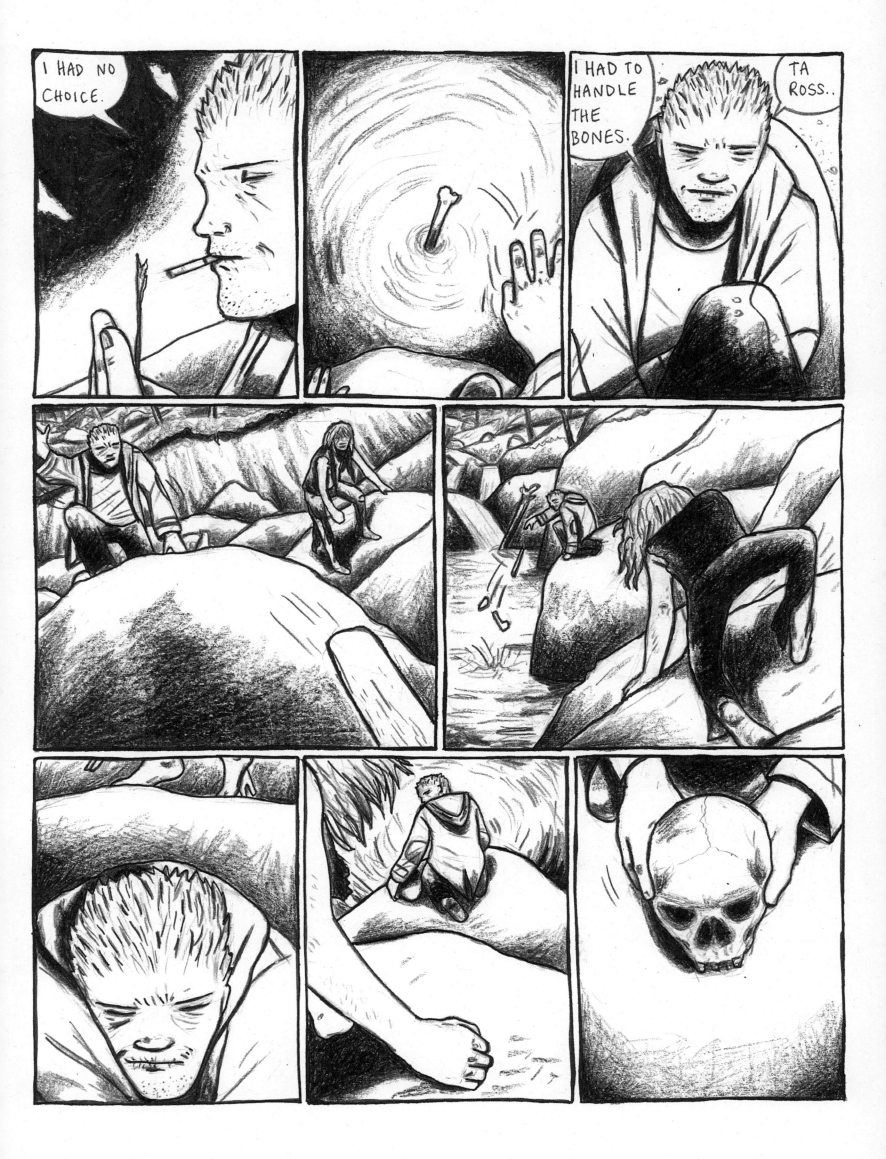

LIST OF WORKS AND CREDITS

Laylah Ali
UNTITLED, 2002
Gouache, watercolour pencil and ink on paper
22.2 x 36.8
CAP Collection
Courtesy 303 Gallery, New York

Laylah Ali
UNTITLED, 2002
Gouache, watercolour pencil and ink on paper
24.1 x 16.5
CAP Collection
Courtesy 303 Gallery, New York

Laylah Ali
UNTITLED, 2002
Gouache, watercolour pencil and ink on paper
26 x 29.2
CAP Collection
Courtesy 303 Gallery, New York

Glen Baxter
LOOKS LIKE YOUR SLIPPING INEXORABLY INTO FIGURATION, 2006
Ink and crayon on paper
135 x 112
Courtesy Flowers Gallery, London

Glen Baxter
A SPATE OF HEPWORTH RUSTLING WAS SPREADING ALARM
ALONG THE TEXAS BORDER, 2006
Ink and crayon on paper
134 x 108
Courtesy Flowers Gallery, London

Stéphane Blanquet
6 drawings for LA VÉNÉNEUSE AUX DEUX ÉPERONS,
pgs. 120-125, 2007 (Cornélius), 2001
India ink on paper
Each 29.7 x 21
Courtesy the artist
© Stéphane Blanquet and Cornélius, 2007

Daniel Clowes
5 drawings for DAVID BORING NO. 21, pgs. 1-5, 2000
(Fantagraphics)
India ink on Bristol board
Each 50.8 x 36.8
Courtesy the artist and Richard Heller Gallery, Los
Angeles

R. Crumb
4 drawings for AMERICAN SPLENDOR ASSAULTS THE MEDIA,
pgs. 75-78, 1983 (Four Walls Eight Windows)
Ink, White-Out and media on paper
Each 43 x 35.4
Courtesy the artist, Paul Morris and David Zwirner

Liz Craft
THE PONY, 2004
Aluminium
100 x 198 x 102
The Zabludowicz Art Trust
Courtesy Alison Jacques Gallery, London and
Marianne Boesky Gallery, New York

Adam Dant
NON-VERBAL COMMUNICATION, 2003
Ink and wash on paper
151 x 101.5
Private Collection, New York

Adam Dant
10 drawings for DONALD PARSNIPS DAILY JOURNAL, 1995-
1999
Ink on paper and papyrus
Dimensions variable
Courtesy the artist and Hales Gallery, London

Julie Doucet
6 drawings for MY NEW YORK DIARY, pgs. 27-32, 1999
(Drawn & Quarterly)
Ink on paper
Each 32.5 x 21.5
Courtesy the artist

Debbie Drechsler
8 drawings for TOO LATE, DADDY'S GIRL, pgs. 49-56,
1995 (Fantagraphics)
Ink on paper
Each 21.5 x 23.5
Courtesy the artist

Marcel Dzama
UNTITLED, 2004
Watercolour on paper
35 x 28
Private Collection

Marcel Dzama
UNTITLED, 2004
Watercolour on paper
35 x 28
Collection of Francis B. Fung

Marcel Dzama
UNTITLED, 2004
Watercolour on paper
35 x 28
Collection of Susan Hiller

Marcel Dzama
NEW HOPE, 2003-04
Collage; 3 ring binder with 30 pages bound, one
page taped to back cover
25.1 x 21.6 (closed)
Courtesy the artist and Timothy Taylor Gallery,
London

Melinda Gebbie
4 preparatory sketches for LOST GIRLS: BOOK ONE,
1989-1992
Crayon, ink and pencil
Each 59.4 x 42
Courtesy the artist

Mark Kalesniko
7 drawings for MAIL ORDER BRIDE, pgs. 20-26, 2001
(Fantagraphics)
Ink on Illustration board
Each 48.3 x 27.9
Courtesy the artist

Kerstin Kartscher
FLOW AND ARREST OF THOUGHTS, 2001
Ink marker, hybrid pen on paper, collage paper on paper
79 x 58
Courtesy Anneke Lucas

Kerstin Kartscher
HAZARDOUS YOUTH, 2003
Ink marker on paper
30 x 42
Courtesy Galerie Giti Nourbakhsch, Berlin

Killoffer
6 drawings for SIX HUNDRED AND SEVENTY-SIX
APPARITIONS OF KILLOFFER, pgs. 2-3 & 42-45, 2002
Ink on paper
Each 54.8 x 37.8
Courtesy Centre National de la Bande Dessinée et
de l'Image
© Killoffer and L'Association, Paris, 2002; Typocrat,
2005 for English language

Kerry James Marshall
Panel from KIN4> 6 LNK , 2006
Ink on drafting vellum
63.5 x 70
Courtesy of the artist and Jack Shainman Gallery,
New York

Kerry James Marshall
Panel from KIN4> 6 LNK , 2006
Ink on Bristol board
28 x 45
Courtesy of the artist and Jack Shainman Gallery,
New York

Kerry James Marshall
Panel from KIN4> 6 LNK 2006
Ink on Bristol board
26.5 x 40.5
Courtesy of the artist and Jack Shainman Gallery,
New York

Chad McCail
UNTITLED, 2007
Gouache on paper
86.4 x 162.6
Courtesy the artist

Chad McCail
UNTITLED, 2007
Gouache on paper
86.4 x 162.6
Courtesy the artist

Paul McDevitt
FIRST DATE, 2005
Colour pencil and ink on paper
50.5 x 50
Courtesy the artist and Stephen Friedman Gallery,
London

Paul McDevitt
GHOST OF DECLAN CLARKE (AFTER HOKUSAI), 2005
Colour pencil, ink and vinyl on paper
48 x 47
Courtesy the artist and Stephen Friedman Gallery,
London

Travis Millard
BRAYED HOME, 2006
Ink on paper
43.2 x 35.5
Courtesy the artist and Richard Heller Gallery, Los
Angeles

Travis Millard
HOME TOWN, 2006
Ink on paper
57 x 76.2
Courtesy the artist and Richard Heller Gallery,
Los Angeles

Travis Millard
SALLY, 2004
Ink on paper
15.2 x 10
Courtesy the artist and Richard Heller Gallery,
Los Angeles

Yoshitomo Nara and David Shrigley
UNTITLED (PHILIP GUSTON'S LUNG), 2002
Mixed media on paper
41 x 45
Courtesy the artists and Stephen Friedman Gallery,
London

Yoshitomo Nara and David Shrigley
UNTITLED (IF YOUR SOUL IS NOT.....), 2002
Mixed media on paper
26.5 x 23
Courtesy the artists and Stephen Friedman Gallery,
London

Kim L. Pace
NEW COMMISSION FOR NEW ART GALLERY WALSALL
AND NOTTINGHAM CASTLE, 2007
Acrylic paint
Dimensions variable
Courtesy the artist

Kim L. Pace
5 drawings for CIRCUS, CIRCUS, pgs. 2, 6, 9, 12, 14,
2006
Pencil on trace
Each 29.5 x 21
Courtesy the artist

Raymond Pettibon
NO TITLE (EVER LOOKING FOR), 2001
Ink on paper
19.4 x 45.7
Private Collection

Raymond Pettibon
NO TITLE (SCIENCE GROWS UP ...), c.1980
Pen and ink on paper
27.9 x 21.6
Private Collection

Raymond Pettibon
NO TITLE (VAVOOM, YOU SEE ...), 1989
Pen and ink on paper
35.6 x 27.9
Private Collection

Olivia Plender
5 drawings for THE MASTERPIECE, ISSUE 1,
STRANGE ADVENTURES, 2001
Graphite on paper
Each 29.5 x 21
Courtesy the artist

Jon Pylypchuk
SO THEN WE WILL BURN YOU WHEN YOU ARE DEAD,
2006
Wood, wood glue, fake fur, hot glue, watercolour,
polyurethane and cotton
244 x 203 x 203
The Saatchi Gallery, London

James Pyman
CAPTURE HILL '78, 1999
Pencil on paper
122 x 236
Courtesy the artist

James Pyman
4 drawing for WILF - A LIFE IN PICTURES, pgs. 16, 56,
63, 70, 2004 (Norwich Gallery NSAD)
Ink on paper
Dimensions variable
Courtesy the artist

Joe Sacco
9 drawings for PALESTINE, Chapter 8, pgs.
73-81, 1994 (Fantagraphics)
Ink on Bristol board
Each 45.8 x 30.5
Courtesy the artist

David Shrigley
CAT BASKET NO.2, 2003
Wicker basket and polyurethane foam
50 x 45 x 45
Courtesy the artist and Stephen Friedman Gallery,
London

David Shrigley
PET CARRIER NO.2, 2002
Pet carrier, expanding polyurethane foam,
acrylic paint
41 x 90 (height x diameter)
Courtesy the artist and Stephen Friedman Gallery,
London

David Shrigley
STRANGE TOY FOR STRANGE CHILD, 2002
Fabric, polystyrene balls, felt pen
8000 x 8 (length x diameter)
Courtesy the artist and Stephen Friedman Gallery,
London

David Shrigley and Chris Shepherd
WHO I AM AND WHAT I WANT, 2005
DVD
7 minutes, 23 seconds
Courtesy the artists

Posy Simmonds
2 drawings for GEMMA BOVERY, Episodes
47, 63, 1999 (THE GUARDIAN)
Ink, crayon, wash, felt-tip and laser-printed
typesetting
Each 42 x 29.7
Courtesy the artist

Richard Slee
BROOMS, 2005
Glazed ceramic and found objects (plastic and
painted bamboo)
6 in total, each 133 x 16 x 17
Courtesy the artist and Barrett Marsden Gallery,
London

Richard Slee
NECKLACE (FOR BUNNY), 2006
Glazed ceramic
18.5 x 1.2
Courtesy the artist and Barrett Marsden Gallery,
London

Richard Slee
PISTOL, 2007
Plastic, brass, enamel
139 x 15 x 10.5
Courtesy the artist and Barrett Marsden Gallery,
London

Richard Slee
S, 2005
Glazed ceramic with found metal hook
47 x 20 x 5
Courtesy Gary Witham

Carol Swain
5 drawings for FOOD BOY, pgs. 60-65, 2004
(Fantagraphics)
Ink and pencil on paper
31.8 x 29.5
Courtesy the artist

All measurements are in centimetres and are height x
width x depth unless otherwise stated.

ADDITIONAL PICTURE CREDITS
p. 6, Kerstin Kartscher, PRACTICING HER PROFESSION
(Detail), 2005, Courtesy Collection H. Schwarz,
London; p. 12 bottom, Courtesy 303 Gallery, New
York; p. 14, © DACS, London/VAGA, New York
2007 / Courtesy Private Collection, Chicago, photo:
© Museum of Contemporary Art, Chicago; p. 16 top
left and right, Reproduced with the kind permission
of King Features, a division of Hearst Corporation;
p.16 middle, © Succession Picasso/DACS 2007 /
Courtesy The Metropolitan Museum of Art, Bequest
of Gertrude Stein, 1947 (47.106), photo: © 1996
The Metropolitan Museum of Art; p. 16 bottom,
Courtesy Sunday Press Books, © Peter Maresca
2007; p. 17 top, © Succession Picasso/DACS
2007; p.17 middle, From "All-American Men of
War" #89 © DC Comics, All Rights Reserved,
Used with Permission; p.17 bottom, © Estate of
Roy Lichtenstein/DACS 2007 / photo: © Tate,
London 2007; p. 18 top, Courtesy the artists; p. 18
bottom, Dick Tracy® 2007 Tribune Media Services,
Inc. Licensed by Classic Media, Inc., a division of
Entertainment Rights Plc. All rights reserved; p. 19
top, © the artist and Artforum 2007; p.19 bottom,
Collection of Clark Coolidge © The Estate of Philip
Guston 2007/ Courtesy McKee Gallery, New York;
p. 20 top left, © The Estate of H.M. Bateman
2007; p. 20 top right, Courtesy the artist; p. 21,
Reproduced with the kind permission of King
Features, a division of Hearst Corporation;
p. 42, Courtesy the artist and Timothy Taylor
Gallery, London; pp.54–55, Courtesy the artist
and Glasgow City Council (Museums) 2007; p. 60,
Courtesy David Zwirner, New York; p. 65, Courtesy
Alison Jacques Gallery, London.

1. Your full name

2. How do you define the line between a cartoonist and an artist?

3. Which artist has had the greatest influence on your work?

4. Which comic has altered your world view?

5. Is humour important in your work?

6. Which comic character do you identify with?

Your full name.

Laylah Ali

How do you define the line between a cartoonist and an artist?

Cartoonist: Image usually works in concert w/ a narrative or story line. Comprehensible story tends to be more central to cartooning.

Which artist has had the greatest influence on your work?

Jacob Lawrence + Ida Applebroog come to mind.

Which comic has altered your world view?

Palestine by Joe Sacco.

Is humour important in your work?

Yes, pointless negative sort.

Which comic character do you identify with?

Thought about it. None.

Your full name.

GLEN BAXTER

Which comic has altered your world view?

NANCY by ERNIE BUSHMILLER

How do you define the line between a cartoonist and an artist?

SHAKILY

Is humour important in your work?

ABSOLUTELY NOT.

Which artist has had the greatest influence on your work?

GIORGIO di CHIRICO

Which comic character do you identify with?

ST. JEROME

Your full name.

How do you define the line between a cartoonist and an artist?

Which artist has had the greatest influence on your work?

Which comic has altered your world view?

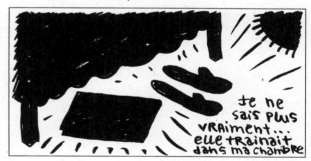

Is humour important in your work?

Which comic character do you identify with?

Your full name.

Elizabeth
Jean
Craft

How do you define the line between a cartoonist and an artist?

cartoonist have
stricter guidelines

Which artist has had the greatest influence on your work?

James Brown
R.I.P

Which comic has altered your world view?

the only things that
have altered my world
view are airplane travel,
mushrooms, and pregnancy

Is humour important in your work?

Yes, I like jokes

Which comic character do you identify with?

none
maybe wonderwomen
the clear jet is
pretty nice

Your full name.

ROBERT DENNIS CRUMB

YEAH
THAT'S
RIGHT:
DENNIS

Which comic has altered your world view?

"SUDS" BY BUCKWHEAT FLORIDA, JR., WHICH CAME OUT IN 1969, I BELIEVE, HAD A HUGE EFFECT ON MY WORLD VIEW!

How do you define the line between a cartoonist and an artist?

I DON'T KNOW... HOW DO YOU DEFINE AN "ARTIST"? OFTEN ACTORS, MUSICIANS, EVEN DANCERS, ARE REFERRED TO AS "ARTISTS"... SO, WITHIN THIS BROAD DEFINITION OF AN "ARTIST", ONE MIGHT SAY THAT CARTOONISTS ARE ALSO "ARTISTS". CRITICS USED TO MAKE THE DISTINCTION BETWEEN "ARTISTS" AND "ILLUSTRATORS", PUTTING ILLUSTRATORS IN AN INFERIOR POSITION... "HE'S A MERE ILLUSTRATOR"... IN THIS VIEW, THE CARTOONIST WAS SEEN AS A LOWLY ENTERTAINER, WITH SOME CARTOONISTS BEING MORE "ARTISTIC" THAN OTHERS, SUCH AS GEORGE HERRIMAN, CREATOR OF "KRAZY KAT." THIS ICEY JUDGMENT OF CARTOONISTS AND ILLUSTRATORS IS JUST NOW BEGINNING TO THAW, AND PERHAPS IT'LL COME TO THE POINT WHERE WORKS DONE FOR PRINT, FOR MASS CONSUMPTION, WILL BE JUDGED ON THEIR OWN TERMS AND NO LONGER BE CONSIGNED EN MASSE TO A POSITION INFERIOR TO WORKS DONE ONLY FOR THE WORLD OF ART GALLERIES, WEALTHY PATRONS & MUSEUMS.

Is humour important in your work?

IS HUMOR IMPORTANT IN MY WORK, YOU ASK? WELL, YEAH... I WANT MY WORK TO BE FUNNY, GET SOME LAUGHS, BUT I'M NOT A JOKE TELLER. I CAN'T DELIVER A PUNCH LINE. IN THAT SENSE, I'M NOT A NORMAL CARTOONIST. I'M NOT EVEN A SATIRIST, IN THE STRICT SENSE... I GUESS MY HUMOR IS KIND OF DARK AND PERSONAL... YOU EITHER APPRECIATE IT OR YOU DON'T... THERE ARE PLENTY WHO DON'T... SOME EVEN CONSIDER MY WORK HATEFUL, NASTY, OVERLY MISANTHROPIC AND NEGATIVE. I'M ALWAYS GRATEFUL AND RELIEVED WHEN SOMEBODY REALLY GETS THE HUMOR.

Which artist has had the greatest influence on your work?

THE ARTIST WHO HAD THE GREATEST INFLUENCE ON MY WORK WAS MY OLDER BROTHER CHARLES, WHO PSYCHOLOGICALLY DOMINATED ME IN OUR CHILDHOOD AND ADOLESCENCE. I DESPERATELY NEEDED HIS APPROVAL FOR ALL MY WORK, AND DREW COMICS AND CARTOONS MOSTLY TO PLEASE HIM. IF NOT FOR HIM, I MIGHT NEVER HAVE BECOME AN ARTIST/CARTOONIST AT ALL. I DON'T KNOW WHAT I WOULD'VE BECOME — SCHOOL TEACHER? BOOKSHOP EMPLOYEE? SOMETHING ALONG THOSE LINES, IMPOSSIBLE TO SAY...
AS A KID I WAS INFLUENCED BY COMIC BOOKS, T.V. SHOWS & MOVIES. I NEVER SAW FINE ART OR EVEN OLDER CARTOON ART FROM BEFORE I WAS BORN UNTIL I WAS AROUND 17 YEARS OLD & REALLY BEGAN MY OWN RESEARCH AND SELF-EDUCATION.

Which comic character do you identify with?

I GUESS I WOULD HAVE TO SAY THAT THE COMIC CHARACTER I IDENTIFY WITH THE MOST IS SHABNO THE SHOE-HORN DOG.

Your full name.

Adam Dant

How do you define the line between a cartoonist and an artist?

Which artist has had the greatest influence on your work?

Pieter Bruegel

Which comic has altered your world view?

Having my joke printed on The Beano letters page made me realise that comics were produced by real & not imaginary people, a fact reinforced by the arrival of a prize.

The joke was the "but that's not my dog!" joke" printed inside a drawing of a hand with a bandaged finger.

Is humour important in your work?

Even though some of the drawings are meant to provoke laughter, sometimes it remains difficult to tell whether the work has been understood or 'got'.

Which comic character do you identify with?

Donald Parsnips?

Your full name.

julie doucet

How do you define the line between a cartoonist and an artist?

as a cartoonist people expect you to do the same thing over and over again. as an artist people expect you to try new things, to explore.

Which artist has had the greatest influence on your work?

i cannot think of an artist having as much of an influence on me and my work than the writer Christiane Rochefort. a french writer, late fifties. i first read her books as a pre-teenagn...she was a feminist, very much anti-establishment her books are angry but so full of life. it was the first time ever i could relate to a female caracter in literature comics, etc... Roger Vadim adapted one of her books to a film "Les stances à Sophie", starring Brigitte Bardot. C. Rochefort was not too happy with the result.

Which comic has altered your world view?

"Le concombre masqué" by Mandryka. french, from the seventies. the two main caracters are a cucumber and a turnip. they live in a made up world. wild imagination. absurd humour. kind of the french Herrimann.

Is humour important in your work?

yes and no. i am not really TRYING to be funny... i don't know. i am just being myself....?

Which comic character do you identify with?

tintin. ah!..

Your full name.

Debbie Drechsler or, if you're my parents
and angry at me, Deborah Sue Drechsler.

Which comic has altered your world view?

Out of all comics? Right now?
Can't think of any, .
But I don't read many comics these days.

How do you define the line between a cartoonist and an artist?

I don't.

Is humour important in your work?

Yes.

Which artist has had the greatest influence on your work?

There are so many, I can't name just one! A partial
list would include Ben Shahn, Antonio Frasconi, Kathë
Kollwitz, Maxfield Parrish, Lynda Barry, Pierre Bonnard,
Charlotte Salomon, Florine Stettheimer, Wanda Gàg,
Hilary Knight, John Tenniel, Ernest H. Shephard, Fritz
Eichenberg, James Whistler

Which comic character do you identify with?

Ernie Pook's Comeek.

Your full name.

Which comic has altered your world view?

How do you define the line between a cartoonist and an artist?

Is humour important in your work?

5.

INdeed ████ humour is pretty important,

Which artist has had the greatest influence on your work?

3.

That would be William Blake. he is the
reason I first started using watercolour
paints, but it could be Marcel Duchamp.
███ Duchamp was the first artist book
I ever took out of the library, because
his first name was the same as mine.

Which comic character do you identify with?

Your full name.

How do you define the line between a cartoonist and an artist?

CARTOONIST THE LINE ARTIST

Which artist has had the greatest influence on your work?

MY DAD - GORDON HUGH GEBBIE

Which comic has altered your world view?

BASIL WOLVERTON'S END OF THE WORLD SCENARIO AS FEATURED IN WATCHTOWER MAGAZINE WHICH I READ DURING THE CUBAN MISSILE CRISIS

Is humour important in your work?

I KNOW YOU ARE BUT WHAT AM I?

Which comic character do you identify with?

CLINT CLOBBER - HE SHOWED ME WHAT COULD BE ACHIEVED BY A FEW BASIC SKILLS AND A CAN-DO ATTITUDE

Your full name.

MARK GASTON KALESNIKO

How do you define the line between a cartoonist and an artist?

I BELIEVE CARTOONISTS ARE ARTISTS.

Which artist has had the greatest influence on your work?

EGON SCHIELE - WHEN I FIRST SAW HIS WORK IT BLEW MY MIND. SCHIELE PAINTS HIS FEELINGS, HIS FEARS, HIS LUSTS. BE IT A NUDE, A PORTRAIT OR A FLOWER. HIS WORK OOZES SENSUALITY.

Which comic has altered your world view?

NONE.

Is humour important in your work?

IF THE STORY REQUIRES IT, I PUT IT IN. BUT MOSTLY THE HUMOUR ARISES OUT OF THE SITUATION.

Which comic character do you identify with?

DONALD DUCK BY CARL BARKS
HE IS THE CLASSIC EVERYMAN. HE IS NOT RICH LIKE UNCLE SCROOGE, HE IS NOT LUCKY LIKE GLADSTONE GANDER AND HE'S NOT SMART LIKE HIS NEPHEWS, BUT HE PERSEVERES.
ALSO I LOVE HIS RAGE.

Your full name.

Kerstin Kartscher

Which comic has altered your world view?

How do you define the line between a cartoonist and an artist?

I would not want to define
why should I

Is humour important in your work?

humor with charm is good
anywhere

Which artist has had the greatest influence on your work?

I'm attached to single works
by artists like - Joseph Cornell,
Robert Filliou, Hannah Hoech,
Florine Stettheimer . . .

Which comic character do you identify with?

none
go away
you should not be here when
our parents are out

Your full name.

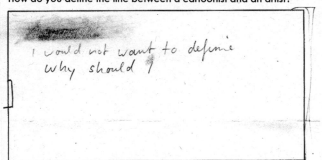
KIL LOF FER

Which comic has altered your world view?

How do you define the line between a cartoonist and an artist?

RIEN

Is humour important in your work?

HA HA!

Which artist has had the greatest influence on your work?

RIEN

Which comic character do you identify with?

KIL LOF FER

Your full name.

Chad McCail

How do you define the line between a cartoonist and an artist?

An anxious one.

Which artist has had the greatest influence on your work?

William McCail and later Jenny Holzer.

Which comic has altered your world view?

I enjoyed Osama Tezuka's Buddha.

Is humour important in your work?

Yes - but I don't set out be funny. If I'm lucky the seriousness gets tight enough to create a moment of self-recognition or absurdity and the tension breaks.

Which comic character do you identify with?

I like Hunt Emerson's Calculus Cat and Robert Crumb's Mode O'Day stories with Doggo.

Your full name.

PAUL McDEVITT

How do you define the line between a cartoonist and an artist?

I ALWAYS IMAGINED IT WAS DIFFICULT BEING A CARTOONIST ILLUSTRATING COMICS, ESPECIALLY MAINTAINING THE LIKENESSES OF MULTIPLE CHARACTERS THROUGHOUT.

Which artist has had the greatest influence on your work?

I THOUGHT ABOUT THIS FOR A WHILE, AND I HAVE NO IDEA.

Which comic has altered your world view?

I DON'T KNOW ABOUT WORLD VIEW, BUT WHEN I WAS YOUNG I WAS HUGELY IMPRESSED BY JUDGE DREDD. THE MEGA CITY WORLD SEEMS MORE LIKE A SERIES OF PERCEPTIVE PROPHECIES WITH EVERY PASSING DECADE.

Is humour important in your work?

NATURALLY, BUT ITS NOT VERY FUNNY.

Which comic character do you identify with?

EVERYONE FEELS A BIT LIKE THE SILVER SURFER AT ONE TIME OR OTHER. AND NEVER LIKE REED RICHARDS.

Your full name.

Travis ~~████~~ Millard

Which comic has altered your world view?

Joe Sacco's,

~~████████████████████~~

Not exactly Altered, more enhancing.

How do you define the line between a cartoonist and an artist?

"Cartoonist" ~~████~~ think "cartoonist" is a term ~~████~~ "artist" umbrella in working specific to the medium ~~████~~ in my mind ~~████████████████~~ People ~~████████████████████████~~ categories, but I tend to judge them on their own merits. I like them crude, raw, adventurous and funny. ~~████~~ either really good, ~~████████████████~~ impacts or really bad... I feel too personally involved to make a ~~████~~ (just as clear distinction between the two. which can be → interesting)

Is humour important in your work?

I try to tell the joke
but whether or not it's funny
is up to the audience.

Which artist has had the greatest influence on your work?

~~████████████████████████~~
~~████████████~~ work, i would probably dodge the question. ~~████~~ My attention is too ~~████████~~ ~~████████████████~~. Most of my influences are just as common or embarrassing ~~██~~ as any one else born in the mid 70's.

Which comic character do you identify with?

The Dude with No Pants On, but slightly ~~████~~ more modest.

Your full name.

YOSHITOMO NARA

Which comic has altered your world view?

It was not comic
but
Music!

How do you define the line between a cartoonist and an artist?

I can't define it!

Is humour important in your work?

I don't know.....
what do you think?

Which artist has had the greatest influence on your work?

NOBODY
OR
EVERYBODY

Which comic character do you identify with?

I don't know......
Do you know?!

Your full name.

Kim L. Pace

How do you define the line between a cartoonist and an artist?

(quite fluffy with feathered ends)

Which artist has had the greatest influence on your work?

Eva Hesse's personal writing had a big impact some years ago.

Which comic has altered your world view?

The Beano, the Dandy & the Financial Times

Is humour important in your work?

Yes

Which comic character do you identify with?

Wonder Woman on a good day, She-Hulk on a bad one.

Your full name.

Olivia Plender

How do you define the line between a cartoonist and an artist?

Different distribution networks — generally speaking comics have the potential, as printed matter, to reach a mass audience whereas artists distribute their work through a fairly elitist network of galleries & museums.

Which artist has had the greatest influence on your work?

In recent years, Öyvind Fahlström.

Which comic has altered your world view?

David Boring
Little Nemo in Slumberland
Krazy Kat

Is humour important in your work?

Yes

Which comic character do you identify with?

Ignatz Mouse

Your full name.

Jonathan MARK PYLYPCHUK

How do you define the line between a cartoonist and an artist?

i have no idea.

Which artist has had the greatest influence on your work?

Combination of Adrian Williams & Michael Dumontier

Which comic has altered your world view?

Family Circus

Is humour important in your work?

sure

Which comic character do you identify with?

Yogi bear.

Your full name.

James Pyman

How do you define the line between a cartoonist and an artist?

Charles M. Schulz's comic strip Peanuts was first published on 2nd October 1950. Its creation at the midpoint of the century located it as the pivot between earlier cartoon stories such as Popeye, Gasoline Alley and Krazy Kat with their screwball, folksy, old-time qualities and the brasher, post-war eras of Mad Magazine media satire, E.C. horror comics and the undergrounds. It is a measure of its significance that there exists a pre- and post-Peanuts sensibility.

Which artist has had the greatest influence on your work?

Schulz began his creative career at the same cultural moment as equivalent American literary stylists such as Charles Bukowski, Philip K Dick and William Burroughs. All made work that reflected a shifting geopolitical landscape and the dawn of the information society. Bukowski's poeticised alienation was profoundly informed by his German parentage, Dick described alternate worlds where even reality is reduced to a commodity, and Burroughs methodically documented the rapidly burgeoning counterculture. Schulz compulsively wrote and drew a daily comic strip for 50 years minutely detailing the existences of a group of young children in a suburban American landscape.

Which comic has altered your world view?

When, in late February 1971, Charlie Brown tried to emotionally manipulate Snoopy by talking about having to work long hours to pay for a dog collar, Snoopy took off said collar and held it out to his owner in symbolic rejection. The visual jolt of that gesture was not simply because you could see, exposed, the beagle's naked throat. It was also because the familiar scratchy line demarcating where Snoopy's head ended and his body began was missing. Like Mickey Mouse without ears, or Hitler minus the moustache, the removal of that tiny but key element of Snoopy's visual DNA changed the reader's perception completely. In that moment Schulz's greatest creation was revealed as simultaneously an independent being with free will and a few squiggly black lines on newsprint.

Is humour important in your work?

Aside from Snoopy's daydreaming, Peanuts seldom strays from the streets and backyards of Schulz's native Minnesota. An atmosphere of honest, blue collar existence permeates every strip's line and word. Charlie Brown waiting outside the neighbourhood barber's shop for his father to finish cutting hair precisely echoes Schulz's own childhood. Every exchange, argument or anecdote has a similarly autobiographical source. Strips rarely end with written punchlines or visual pay-offs. The complexity of Schulz's four-panel narrative is such that often the 'gag' occurs before the story's conclusion and the final panel functions as either a postscript or a prelude to potential future events.

Which comic character do you identify with?

At age 9, 10, whenever, sitting at the table listening to Led Zeppelin IV and pasting into a scrapbook the six Peanuts strips that I'd meticulously clipped out of the previous week's Daily Mails.

Your full name.

Joe J. Sacco

How do you define the line between a cartoonist and an artist?

This isn't a question I consider deeply. I know what I do on some level can be defined as art, in that I use a pen and ink on paper. But I define my own art as using words and pictures to tell a narrative story. If the story is told and the reader is propelled along, then I consider my work as an artist accomplished. As to non-cartoonist artists, the ones that have to get into galleries, I feel sorry for them. I'd rather my work was judged in the "marketplace."

Which artist has had the greatest influence on your work?

Among fine artists I'd have to say Pieter Brueghel the Elder. Among cartoonists, it would be Robert Crumb. Both men made whatever they drew come alive.

Which comic has altered your world view?

Perhaps Harvey Pekar's 'American Splendor.' It showed how comics could elevate the stuff of daily life.

Is humour important in your work?

Of course. Ultimately I started doing cartoons to make people laugh. If my motivations are different now, humor still remains important to me. There's a lot of humor even in ugly situations. Often people use humor to maintain their dignity, and that's something I hope my work shows.

Which comic character do you identify with?

Only my own self-characterization. Believe me, it's not Spiderman.

Your full name.

CHRIS SHEPHERD

How do you define the line between a cartoonist and an artist?

I'M NOT SURE I COULD DRAW A ~~LINE~~ LINE BETWEEN A CARTOONIST AND ARTIST. FOR ME IT'S ALL ABOUT STORIES. WHAT GENRE THE AUTHOR SLOTS INTO IS A SECONDARY THOUGHT.

IF I DID TRY TO DRAW THE LINE IT MIGHT LOOK LIKE THIS

Which artist has had the greatest influence on your work?

IN NO PARTICULAR ORDER
DR SEUSS, TARDI, FRANCIS BACON, BILL TIDY, CRUMB, GARY LARSON, BOB GODFREY, DAVID SHRIGLEY, AND ALL THE ALL THE GRAFFITI I'VE SEEN IN STRANGE PLACES.

Which comic has altered your world view?

WHEN I WAS A KID I READ IT NON STOP

Is humour important in your work?

HUMOUR CREEPS INTO THE DARKEST OF DRAMAS. IT'S A MIRROR OF LIFE, THE MOST DESPERATE SITUATION CAN BE FUNNY, AS CAN THE MOST FUNNY SITUATION BE DESPERATE.

Which comic character do you identify with?

Your full name.

DAVID JOHN SHRIGLEY (MR.)

How do you define the line between a cartoonist and an artist?

IT IS A VERY THIN, DOTTED LINE LIKE THIS:

- - - - - - - - - - - -

Which artist has had the greatest influence on your work?

GOD

Which comic has altered your world view?

I DON'T HAVE ● MUCH INTEREST IN COMICS.

Is humour important in your work?

I GUESS SO

Which comic character do you identify with?

BILLY THE FISH

Your full name.

Posy Simmonds

How do you define the line between a cartoonist and an artist?

- It's a line becoming more and more blurred. [The clay sculptures of FISCHLI & WEISS are 3-D cartoons].
- The cartoonist draws for reproduction for a more or less defined audience. NEWSPAPER cartoonists, in particular, know their work is ephemeral and bound to end each day in the bin or lining the guinea pig cage. The artist has no such comforting certainty.
- Artists probably don't get asked:
 Who thinks of your jokes?
 Can you draw properly if you want to?
 What else d'you do?
 Can you draw Bart Simpson for me?

Which artist has had the greatest influence on your work?

Have been influenced by lots of artists...but no one in particular.

Which comic has altered your world view?

None

Is humour important in your work?

Yes

Which comic character do you identify with?

Maybe Morticia Addams.
But only maybe.

Your full name.

How do you define the line between a cartoonist and an artist?

Which artist has had the greatest influence on your work?

Which comic has altered your world view?

Is humour important in your work?

Which comic character do you identify with?

Your full name.

CAROL SWAIN.

Which comic has altered your world view?

'RUPERT THE BEAR.'
'ESCAPE' MAGAZINE
'PICTURE STORY'.

How do you define the line between a cartoonist and an artist?

Is humour important in your work?

NOPE, NOT ESSENTIALLY.

Which artist has had the greatest influence on your work?

JERRY MORIARTY.
GOYA, AND WRITERS SUCH AS BABEL,
GORKY, SCHULTZ, BALLARD.

Which comic character do you identify with?

'JIMBO' BY GARY PANTER
OR 'AMY' BY MARK BEYER.